IMAGES
of America

MUSIC MAKERS
OF THE
BLUE RIDGE
PLATEAU

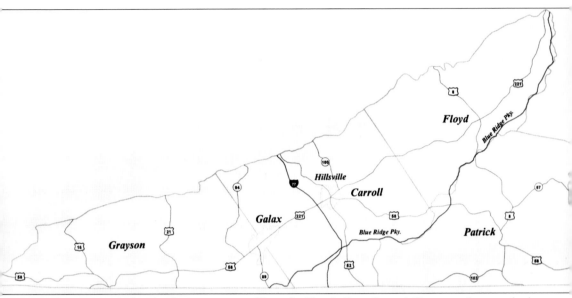

This map includes the four counties of Patrick, Floyd, Carroll, and Grayson along with the city of Galax, which make up the Blue Ridge Plateau area of Virginia. This area is steeped in traditional music, art, crafts, and heritage. (Courtesy Donnie Turner, director of tourism, Blue Ridge Plateau.)

ON THE COVER: R. O. Slusher Jr. on harmonica and Andy Hylton on guitar, first cousins and friends, are on an outing with their families atop Buffalo Mountain in Floyd County in the 1960s. They are entertaining their families after a picnic lunch. Later they would hike up to the top of the mountain. (Courtesy George Slusher.)

IMAGES
of America

MUSIC MAKERS
OF THE
BLUE RIDGE
PLATEAU

Blue Ridge Music Makers Guild, Inc.

ARCADIA
PUBLISHING

Published by Arcadia Publishing
Charleston SC, Chicago IL, Portsmouth NH, San Francisco CA

Printed in the United States of America

Library of Congress Catalog Card Number: 2008922668

For all general information contact Arcadia Publishing at:
Telephone 843-853-2070
Fax 843-853-0044
E-mail sales@arcadiapublishing.com
For customer service and orders:
Toll-Free 1-888-313-2665

Visit us on the Internet at www.arcadiapublishing.com

This book is dedicated to the musicians and instrument builders, past and present, who have shared their love of music and family— essentially their way of life—with the world, not seeking fame and fortune but purely for the enjoyment. May their memories and talents live on through future generations.

CONTENTS

ACKNOWLEDGMENTS

Our special thanks go to the following for their vital contributions to preserving the history of the music of the Blue Ridge Plateau and their gracious permission to use their information in this book: *Strings of Life* by Kevin Donleavy, *First Forty Years of the Old Fiddlers* by Herman K. Williams and the Galax Moose Lodge, *A Hot-bed of Musicians* by Paula Hathaway Anderson-Green, the liner notes for *The Old Time Way* of Heritage Records, and *A Guide to the Crooked Road* by Joe Wilson. We also would like to thank the many people who spent time with us sharing their stories and their pictures. They include Ricky Cox, Buddy Pendleton, Denny Alley, James Shelor, Woody and Jackie Crenshaw, Jimmy Edmonds, Wayne Henderson, Donnie Turner, Dale Morris, Oscar and Laramie Hall, Harold Mitchell, Wade Petty, Phyllis Newman Eastridge, and photographers Mark Sanderford and Dale Plaster. The images used are from the Blue Ridge Music Makers Guild's collection unless otherwise noted.

INTRODUCTION

This book tells some of the story of the creation and preservation of the music of the part of Virginia known as the Blue Ridge Plateau. In each of the five locations the book covers—Grayson County, Galax, and the counties of Carroll, Patrick, and Floyd—a similar pattern emerges. The settlers of the mountains, separated by distance and topography, turned to music as their main form of entertainment and the focus of social gatherings. Theirs was a culture built around farming and neighbors helping neighbors. An integral part of the many shared "workings," such as corn shucking, wood cuttings, quilting, barn raisings, and bean stringing, was the reward of having fun with music and dancing at the end of a hard day. In the winters, when the farm work was less demanding, there was more time to play music either in family groups or neighborhood gatherings. If a neighbor was sick, everyone came over and helped out. It was a time of people making their own living, visiting, and enjoying life.

During this time, each small community had its own one-room schoolhouse. According to *The Old-Time Way*, "An article in *Carroll County, Virginia School* says that in 1934, a total of 95 of the 104 schools in Carroll County were one- and two-room schools." Not only were the children educated at these schools, but they also served as gathering places for school breaks, box suppers, comical skits, and political rallies. Well-respected musicians would be in great demand to play at these gatherings. Sometimes they would even give a concert just for "listening" music.

Many of the musicians would make their own instruments, both out of necessity and convenience. A number of their stories are included in this book. The distance separating the different groups of musicians made for distinct playing styles, also noted in these pages. The fiddle was often played alone by these early musicians. Later the banjo was added, with sometimes two fiddles in a given group. The guitar was the last instrument to be added to the traditional "stringband" sound, as these instruments were harder to come by before the advent of the mail-order catalog.

A number of changes had a huge impact on this traditional music. In the 1940s and 1950s, the little schoolhouses were consolidated into much larger buildings more centrally located. This removed from the little communities an important gathering place. Even before this, in the 1920s, commercial radio was having its impact. People would turn to the radio for their entertainment rather than picking up an instrument. If they chose instead to learn new tunes from the radio, people were learning a much greater variety of songs than they had previously played. In the past, each little community had its favorite tunes and style of playing passed down through the families and learned from outstanding players of that area. Now the radio was threatening to make the local styles and tunes a thing of the past. Fortunately, along with the radio came the recording industry, through which a lot of the traditional music has been captured for us to enjoy today. Some of the history of these recordings and their significance will be discussed in this book. These early recordings also brought the rich abundance of traditional music found in this area to the attention of folk music historians like Alan Lomax and Mike Seeger, who came and made field recordings for Folkways and the Library of Congress. Bobby Patterson also preserved a treasury of this music with Heritage Recordings of Woodlawn.

With the arrival of industry into the area, most notably furniture building in the town of Galax, people began to move away from farming as a way of life. Despite this big change, many still saw the great value of music in the fabric of their lives and have worked to keep the old songs and styles vital. The advent of the fiddlers' conventions has been a very significant factor in keeping the old music alive. As early as 1920, a convention was held in Floyd, Virginia. Being able to win prize money as well as praise attracted many from near and far to compete. A number of communities in this area have held these conventions over the years, but the biggest and best known would have to be the one started in Galax in 1935, still going strong today.

The creation of bluegrass in the 1930s allowed a new way for traditional music to develop here. In bluegrass, the emphasis is more on the individual picker and styles of harmony. The rich tradition of acoustic players found in this area serves bluegrass well. It has been said that in these parts "if you throw a rock you'll either hit a picker or a preacher." In 1963, the Old Fiddler's Convention in Galax split their banjo competition into two categories: "Clawhammer" and "Blue Grass." This was an early indicator of the influence the three-finger style (Earl Scruggs) of banjo playing was having. Then in 1971, they split the band competition into two categories: "Old Time" and "Blue Grass." Many locals have made a mark in the big time with bluegrass bands. Some of their stories are also included in this book.

The people of this area continue to value deeply its musical history and traditions, and many from around the world come to visit (and some resettle), drawn by the roots of traditional "old-time" music and the desire to participate in this rich, musical culture. The songs of the early frontier continue to be played, enjoyed, and nurtured.

The biggest challenge in putting this book together was the vast array of tales to be told in pictures from this area so rich in music. We know we have missed many important stories in the process, but we hope the ones we have included will give at least some idea of how rich this area is in the wonder of music making and how blessed we are to live in such a place. The following poem by an unknown writer could well have been a song. It too tells a story.

Mountain Music Melody

I was born back in the mountains where birds sing freely
And the crickets play their fiddles every night
Coyotes climb the mountain while the big moon is rising
We'd sing and play until the morning light.

I like mountain music, good old mountain music
That drifts through my window every night,
Counting the stars and peeping through the bars
And Mother Nature has a copyright.

The whip-poor-will is singing a sad song about us,
The bullfrog keeps on his solid beat
Halfway through the chorus you can hear the hound's a-baying.
Raccoon's in a white oak down by the stream.

Sometimes in the evening I'm getting sad and lonely
I close my eyes and let my thoughts run free
I'm back there in the cabin by the open window,
And mountain music sweeps me off my feet.

One

GRAYSON COUNTY

Grayson County has made remarkable contributions to the history of music in the Blue Ridge Plateau. This is the birthplace of much that has made this mountain music so special. Styles were invented, instruments built and improved, songs written, and gatherings encouraged where dancers delighted in the good music. The Whitetop area has been called a "hotbed of musicians." Here a unique fiddling style was developed, improved, and passed on by people like Albert Hash and Dave Sturgill. Hash also developed, improved, and passed on the craft of instrument building, beginning with fiddles and then branching out to mandolins, dulcimers, and banjos. Both Wayne Henderson and Tom Barr were his apprentices. In east Grayson, Greenberry Leonard was legendary for his skill and the influence he had on generations of fiddlers, like Emmett Lundy, Luther Davis, and others. The town of Fries has generated from its mill workers the likes of Henry Whitter, who set off the recording boom among Virginia artists with his composition "Wreck of the Southern Old 97" and "The New River Train." Close on his heels at the New York OKEH studios were Ernest Stoneman's "The Titanic" and the band the Hill Billies from Fries and Galax. Jimmy Arnold, a bluegrass and folk rock musician in the 1970s, was also from Fries. Many outstanding musicians at the first Galax Fiddler's Convention were from Grayson County—groups like the Ballard's Branch Bogtrotters. Their story is being carried on by the New Ballard's Branch Bogtrotters. Many others have been carrying on the tradition for years and are mentioned in the subsequent pages.

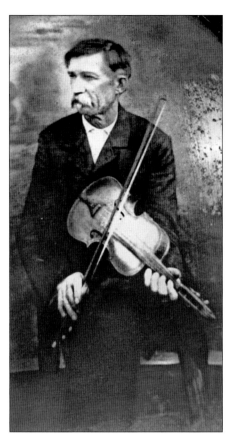

A legendary fiddler of Grayson County was Greenberry "Green" Leonard (1810–1892); even many of the old-time fiddlers named him the best. Emmett Lundy was a student of Leonard's and captured some of his style in later recordings. Lundy said that Green Leonard always used the standard G-D-A-E tuning and that he had to work hard to get the tunes he caught from Leonard. (Courtesy Heritage Records.)

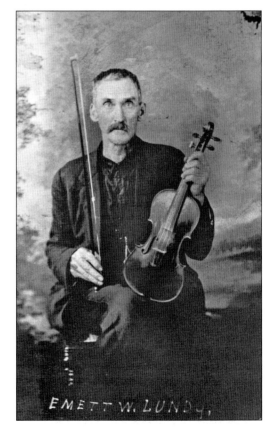

Emmett Lundy (1864–1953) was born in Grayson County. He played for pure enjoyment with friends like Isom and Fielden Rector, Eck Dunford, and Crockett Ward of the Bogtrotters band. Emmett traveled with Ernest V. Stoneman to New York for the OKEH session in May 1925 where they recorded the harmonica/fiddle duets of "Piney Woods Gal" and "The Long Eared Mule." Lundy remained true to the Grayson fiddle tradition. (Courtesy Heritage Records.)

The story of Luther Davis (1887–1986) is best told in the booklet that comes with *The Old Time Way*, Heritage recording No. 070. He played the banjo until he was 15 and also the fiddle. He learned to play from Isom and Fielden Rector and added his own style to what they taught him. Always hunting for tunes, he continued to learn from Friel Lowe, May Lyons, Kelly McKnight, and others. (Courtesy Heritage Records.)

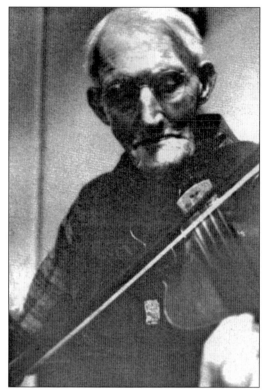

This picture of Parley Parsons (1902–1984) was probably taken in the 1970s. He was a neighbor of Emmett Lundy in Grayson County. Bobby Patterson speculated in *The Old Time Way* that upon Parley's death no one was left who played in the style of Emmett Lundy and Bob Crawford. They had a bow lick that was distinctive. With all the music that has been recorded, some has been lost.

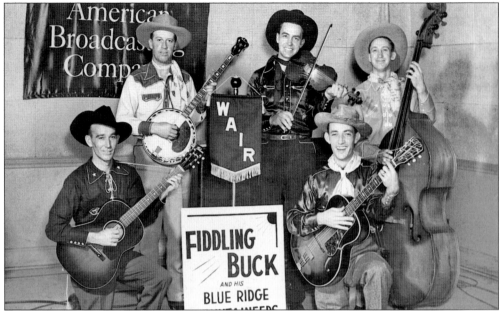

Fiddling Buck and His Blue Ridge Mountaineers regularly played on WAIR, Winston-Salem, North Carolina, from 1948 to 1950. From left to right are (first row) Virgil Cummings and Oscar Vaughn; (second row) Earl Smith (on banjo), Everett Lundy (on fiddle), and Kelly Lundy (on bass). Everett and Kelly Lundy were both sons of Emmett Lundy. Martha Murray (Swanson) of Baywood is a daughter of Earl Smith.

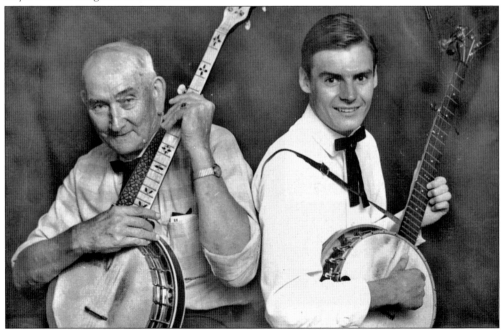

"Uncle" Wade Ward (1873–1864), left, who won first place in banjo at the 1936 Old Fiddlers' Convention, was from Independence. Peter Parish from England (right) heard Wade on a record and had to learn to play like him. Peter came often to the Old Fiddlers' Convention, staying with the Edmonds. He liked it so well here he married a local girl and moved to Independence.

Alex Dunford (1877–1953), called "Uncle Eck" by many, lived modestly playing his fiddle on Ballard's Branch Road and was a founder of the Ballard's Branch Bogtrotters. He was a fine photographer, using a box-style camera and tripod with glass plates to record much of the early history of Galax. His listed occupation in the 1910 census was "artist photographer." This picture, a self-portrait, is an example of his work.

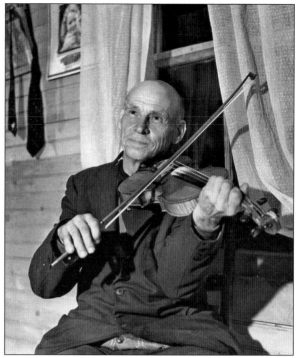

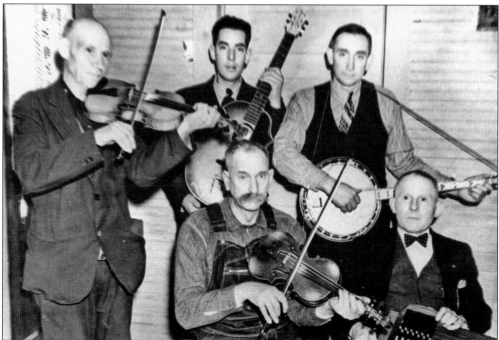

In April 1935, the Old Fiddler's Convention began. The Ballard's Branch Bogtrotters won first place playing "Barney McCoy" and "Susanna Gal." Shown are "Uncle Eck" Dunford on fiddle (left), Crockett Ward on fiddle (center), Dr. Whitefield Davis on autoharp, Wade Ward on banjo, and Fields Ward on guitar. Ballard's Branch is the name of an old northwest section of Galax, home to the Wards, Dunfords, and Pattons.

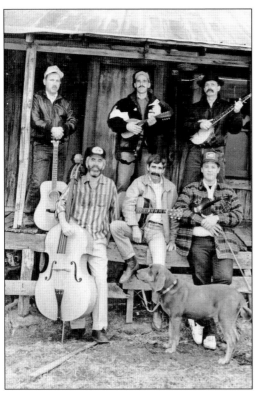

Pictured are the New Ballard's Branch Bogtrotters in 1993. From left to right are (first row) Dale Morris (bass), Dennis Hall (guitar), and Greg Hooven (fiddle): (second row) Mike Brown (guitar), Dallas Hall (mandolin), and Peco Watson (banjo). This picture was taken for their first recording on Heritage Records. They have carried on the wonderful reputation of the Bogtrotters, winning six first-place ribbons in Old Time Band competition at the Old Fiddlers' Convention in Galax.

John Worth Edwards (1898–1994), pictured here around 1925, played a mean old-time banjo with Glenn Nichols (1900–1983) on fiddle. Worth used two tunings on his five-string, high and low, explaining that "Old Joe Clark" is in the low key. "Frailing," "drop thumb," and "clawhammer" described his style. Worth also enjoyed the fiddling of Bruce Reavis (1891–1979) and Joe Caudill.

Glenn Nichols (1900–1983) played often with Worth Edwards (banjo). They were from the Cracker's Neck community, just four miles above the North Carolina line in Grayson County. Tunes they liked were "Mississippi Sawyer," "Holly Ding," "Fly Around," and "Soldiers Joy," to name a few. They would play at dances and schools all over the area. Glenn played on the *Archive of Folk Song* Library of Congress recording.

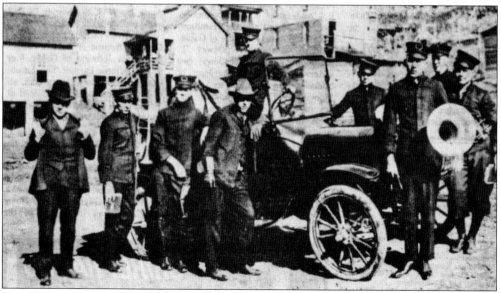

Not all the music in the early days was string music; shown here is part of a brass band in the town of Fries. The picture was probably taken in the 1930s. The *Fries Textile News* lists these men as, from left to right are Kelly Harrell, Jim Harrell, William Bond, Ed Sawyers, Hutch Stata, Nat Hester, Bill Hester, John Sumner, Howard Sumner, and Wilmer Hester. (Courtesy *Fries Textile News*.)

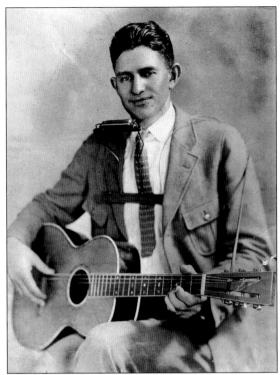

Henry Whitter (1892–1941), a Fries mill hand, played harmonica and guitar and was the first musician from Grayson County to be recorded. In 1923, he traveled to New York City, where his "Wreck of the Southern Old 97" proved to be one of Ralph Peer's early successes. From 1927 to 1930, Whitter recorded songs—still being covered today—with fiddler G. B. Grayson, such as "Banks of the Ohio," until Grayson's untimely death.

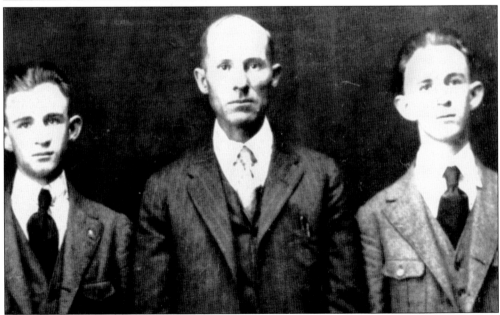

Pictured from left to right are Colen Sutphin (1899–1994), James Franklin Sutphin (1877–1931), and Bolen Sutphin (1899–1972). James was the first fiddle player for Henry Whitter's first band, the Virginia Breakdowners. He lived in Dalton Hollow in Fries and bought and ran the Old Dalton store, later renaming it J. F. Sutphin and Sons. Henry Whitter played guitar, and John Rector played banjo. They traveled to New York in 1923 to record with the OKEH label. (Courtesy Heritage Records.)

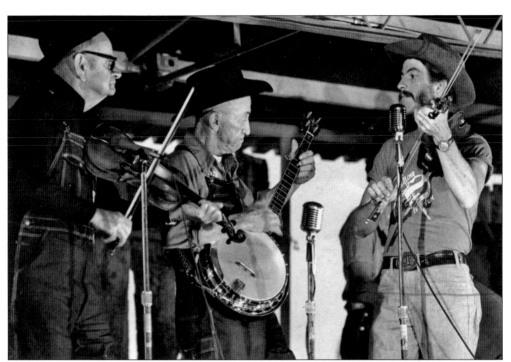

Enoch Rutherford (born 1916) is shown playing the banjo at the Grayson County Fiddler's in Independence, another old and well-respected competition. Dean Ward is the fiddler on the left, and Enoch's son Harvey plays the other fiddle. Five generations of Rutherfords have been making music, playing old tunes like "Fisher's Hornpipe" and "Cumberland Gap." They live in the Gold Hill section of Grayson County.

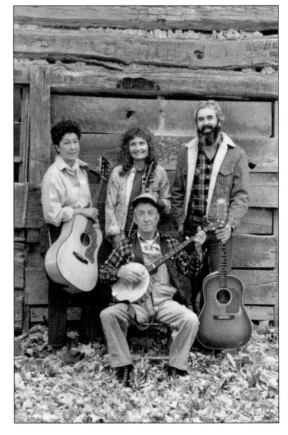

Pictured here is Enoch Rutherford with the Gold Hill Band. The Rutherfords have been living in Gold Hill for many years. Carol Holcomb is the guitarist on the left, Alice Gerrard plays the fiddle, and Dale Morris is the guitarist on the right. (Courtesy Connie Morris.)

The song writing tradition continued in Grayson County in 1964, when J. C. Pierce (left) told the sad story of a 1792 kidnapping in Grayson. Five-year-old Caty Sage was abducted by a white man and sold to the Cherokees. She was then passed to the Wyandottes. She was found by her siblings over 56 years later. The Wolfe Brothers recorded a new version of this story in song on their new compact disc released in 2007.

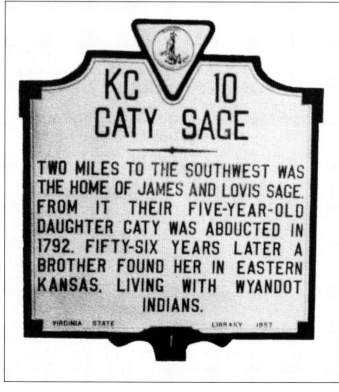

KC 10
CATY SAGE

TWO MILES TO THE SOUTHWEST WAS THE HOME OF JAMES AND LOVIS SAGE. FROM IT THEIR FIVE-YEAR-OLD DAUGHTER CATY WAS ABDUCTED IN 1792. FIFTY-SIX YEARS LATER A BROTHER FOUND HER IN EASTERN KANSAS. LIVING WITH WYANDOT INDIANS.

VIRGINIA STATE LIBRARY 1957

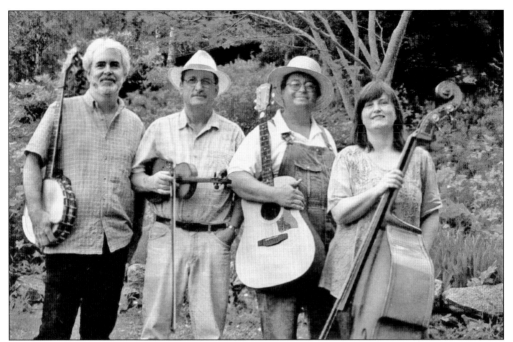

Pictured above is the 2004 version of the Wolfe Brothers String Band of Elk Creek. From left to right, Dale Morris is playing banjo, Jerry Correll is on fiddle, Casey Hash plays guitar, and Donna Correll is on bass. They are still a very active and highly respected old-time band. They have five albums; their latest, *Old Virginia Hills*, is a combination of old and original songs. (Courtesy Connie Morris.)

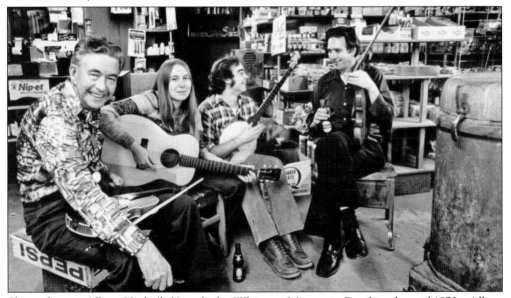

Shown here is Albert Hash (left) with the Whitetop Mountain Band in the mid-1970s. Albert moved away from bluegrass and back to earlier traditional music. This picture includes Flurry Dowe (banjo), a new young picker who had studied clawhammer banjo with Jont Blevins, Emily (guitar), and Thorton Spencer (fiddle at right). Tom and Becky Barr and Becky Haga, a singer and guitar player, not pictured, were also in the band.

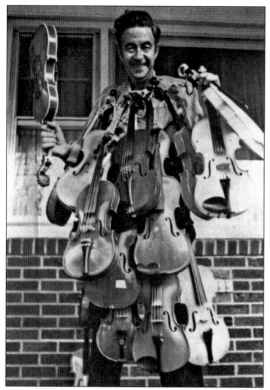

Albert Hash (1917–1983) learned to play the fiddle from his father as well as from many neighbors. He was well known for building and playing fiddles. He also built mandolins, dulcimers, and even some banjos. He was raised in Haw Orchard and built his first fiddle because he could not afford one. He was willing to share his craft, which had a far-reaching impact on instrument building across the Blue Ridge Plateau. He taught both Wayne Henderson and Tom Barr. He noted the African American influence in the music he made. He applied his skill as a machinist to machinery designed for instrument building. His fiddles had intricately carved scrolls and backs. He was nominated for the Heritage Fellowship of the National Endowment for the Arts in 1981. His daughter, Audry Ham Hash, makes fiddles and dulcimers. (Courtesy Martin Fox.)

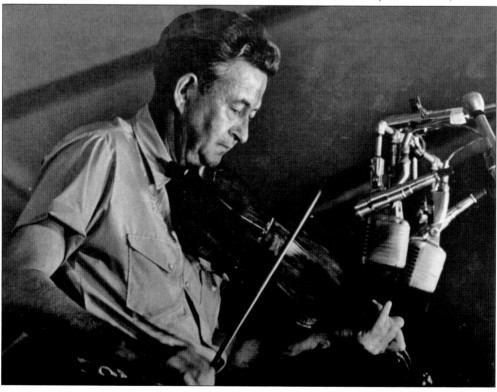

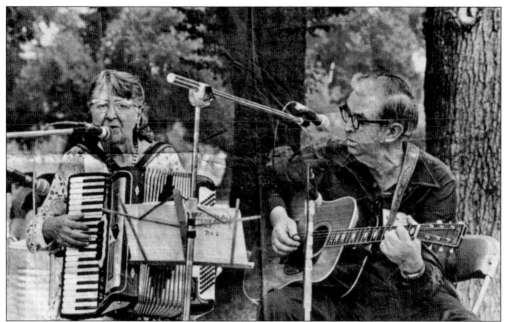

Pictured here are E. C. and Orna Ball, who were friends of Wayne Henderson. The Martin guitar E. C. is playing was a marvel to Wayne, and he was allowed to hold it only while in the middle of a room. It was Wayne's pattern to build himself a dreadnought guitar. E. C. won first place in the guitar competition and Orna first in folk song at the Old Fiddlers' Convention in Galax in 1946.

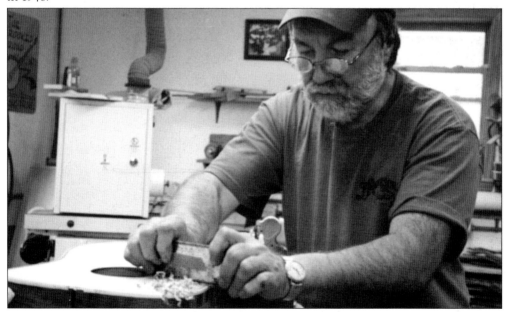

Born in 1947, Wayne Henderson is a native of Rugby. He has built over 408 guitars, 55-plus mandolins, 12 banjos, and one dulcimer. He has worked on instruments for people such as Tony Rice, Doc Watson, John Cephas, and Eric Clapton. Albert Hash was his big inspiration and was the person Wayne turned to when his first guitar fell apart. Albert told Wayne he needed to use white (not black) glue.

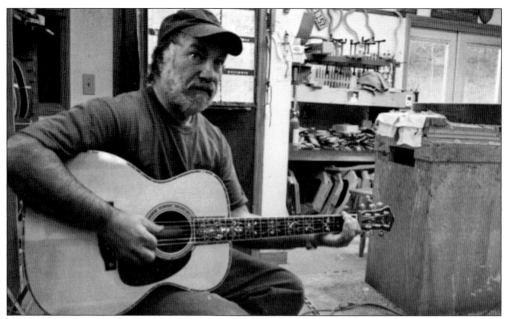

Wayne is shown here playing guitar number seven, which he made in 1968 when he was 21. Wayne used a Martin for patterns but wanted to copy the classy Martin D-45, dripping with pearl. He succeeded by using simple tools: a jackknife, files, and a coping saw—not a jeweler's saw. The sides were bent by wetting the wood and bending it over a hot pipe. (Courtesy Ben Anderson.)

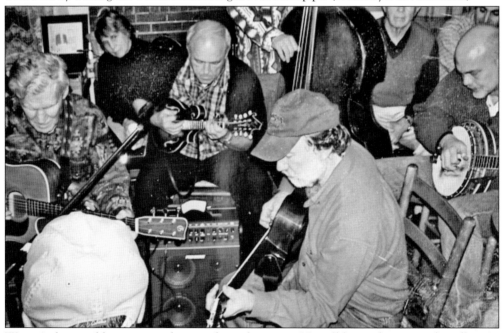

Wayne's shop and home are gathering places for music. He will be working, people will come by to see how he is doing or to pick up their new guitar, and a jam session will break out. Here is a very special jam that happened at Wayne's 2007 Christmas gathering. His good friend and mentor, Doc Watson, is seen here picking with Larry Belvins on mandolin, Sammy Shelor on banjo, and Wayne on guitar. (Courtesy Ben Anderson.)

Gerald Anderson from Troutdale was born in 1954 and carries on the tradition of instrument building. He was an apprentice to Wayne Henderson (1976–2003) through a grant from Folk Life, making guitars and mandolins. He now has a shop of his own. Anderson has made 135 mandolins and 46 guitars. He is an excellent guitar player and singer. He and his apprentice, Spencer Strickland, put on a fine show. (Courtesy Ben Anderson.)

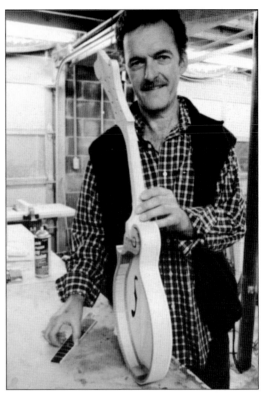

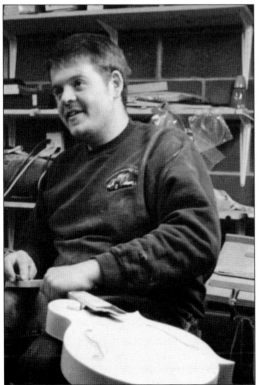

Shown here is Spencer Strickland, who continues the line of instrument builders in Grayson County as an apprentice under Gerald Anderson at his Troutdale shop. Here he is finishing a mandolin, which when done he can play as well. Spencer was delivering a guitar he and Gerald had made to a delighted customer this day. They take custom orders for both guitars and mandolins. (Courtesy Ben Anderson.)

Sharing music with friends in homes continues to be a strong tradition in Grayson County. Above is the home of Blanche and Ellis Nichols, where old-time music get-togethers have been happening for almost 40 years. Blanche is the niece of banjo player Wade Ward, who taught her to play guitar. She married Ellis in 1950, and they began playing square dances and formed the Peach Bottom Band. (Courtesy Ray Chatfield and Helen Newman.)

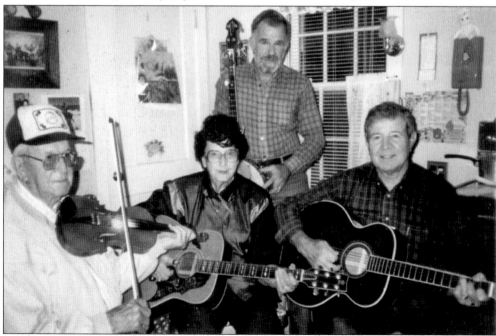

Blanche and Ellis Nichols opened their home to musicians from as far as France and England, often having as many as 30 or 40 musicians in their small kitchen. Ellis had to reinforce the floor to make it safe. He died in 1994, but Blanche continues the tradition with the Kitchen Band. Pictured from left to right are Heath Higgins, Blanche Nichols, Ray Chatfield, and Glen Zuhlke. (Courtesy Ray Chatfield and Helen Newman.)

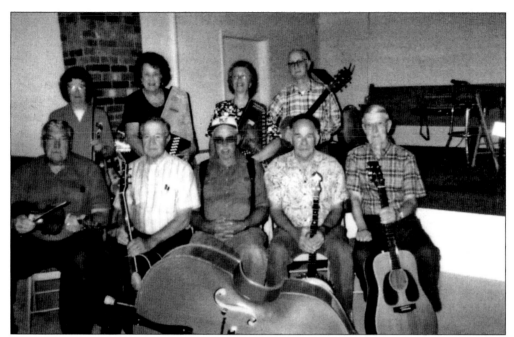

The present-day Kitchen Band, which was formed while playing with Blanche Nichols, is, from left to right, (first row) Roger Wilson, Glen Zuhlke, Elmer Stanley, Ray Chatfield, and Glen Wilson; (second row) Gladys Musser, Nell Zuhlke, Helen Newman, and Gene Hall. (Courtesy Ray Chatfield and Helen Newman.)

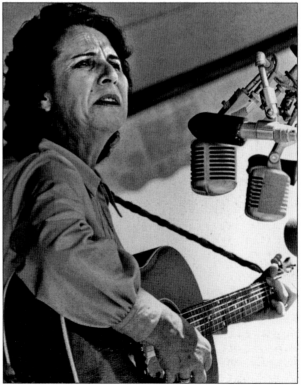

Evelyn Farmer (born 1918) lives in Providence, just below Fries. As a child, she played guitar with her father, Glen Smith. She also sang and played autoharp. She has placed in the folk song competition at the Old Fiddler's Convention and was one of several instrumental in getting autoharp competitions at the local fiddler's conventions. She was often heard playing "The Bells of Saint Mary." Jesse Lovell is her nephew. (Courtesy Oscar and Larmine Hall.)

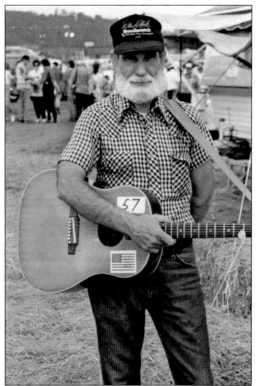

Jesse Lovell (born 1935) lives in the Steven Creek area. He is a well-respected guitar player, folksinger, and songwriter. "The Interstate's Coming through My Outhouse" is one of the most requested songs he sings. He is the grandson of well-known old-time musician Glen Smith. Jesse had a group called the Virginia-Carolina Buddies that included Carlos King on clawhammer banjo.

The Smokey Valley Boys combine the traditional music of Grayson and Surry Counties. Pictured from left to right are Roger Wilson, Benton Flippin, and Gene Hall. Roger Wilson grew up with Charlie Higgins as his neighbor. He plays in the style of Kyle Creed and Fred Cockerham and played with Whit Sizemore, the Wolfe Brothers, Buck Mountain, and others. Gene Hall (born 1931) learned from Wayne Hensdell and played with Kilby Snow. Benton Flippin (born 1920) often won at Galax with the Smokey River Boys. (Courtesy of Roger Wilson.)

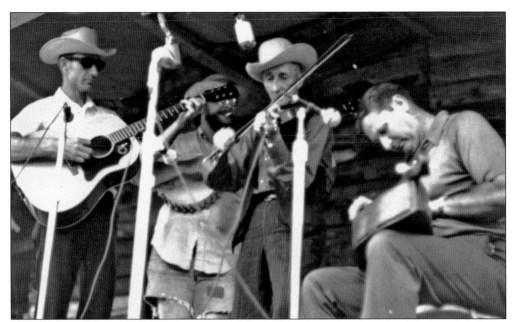

Pictured here are Jesse Lovell (guitar), Ed Fleishman (banjo), Gold Blevins (1904–1981) on fiddle, and Wayne Burcham (dulcimer) at a 1973 fiddler's competition. Gold came from a family rich in music. Gold's grandfather, Haywood (1837–1923), was cited in the 1850 census as a fiddle player. His brother Woody loved to play the piano and brought an organ with him in the back of a pickup truck once. (Courtesy Mark Sanderford.)

Bruce Mastin lived in Spring Valley in Grayson County. He was part of the Spring Valley Boys, who were together from the late 1950s into the mid-1970s. They released one LP in 1971. Bruce's son Alan played bass in the Spring Valley Boys; it was a common occurrence to have two generations in one band. Alan now plays bass with Big Country Bluegrass, a band receiving national acclaim. (Courtesy Mark Sanderford.)

Big Country Bluegrass is, from left to right, Jimmy Trivette (guitar), Alan Mastin (bass), Teresa Sells (guitar), Tom Brantley (fiddle), Tommy Sells (mandolin), and Larry Pennington (banjo). They are still carrying on the traditional sounds of Ted Lundy, Larry Richardson, and Roy McMillan. They have received national acclaim playing straight-ahead bluegrass with vocals from the heart.

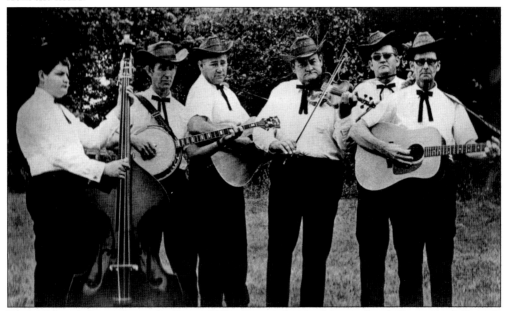

Pictured from left to right are the Spring Valley Boys with Alan Mastin (bass), Sonny Funk (banjo), Kyle Cole (guitar), Bruce Mastin (fiddle), Reed Robertson, and Dale Poe (guitar). They were from Elk Creek. They placed fourth in the band competition in the 1967 Old Fiddlers' Convention. Dale Poe was also a member of the Buck Mountain Band. Poe can be heard performing "Blackberry Blossom" on Galax, Virginia, Old Fiddler's Convention, released by Folkways.

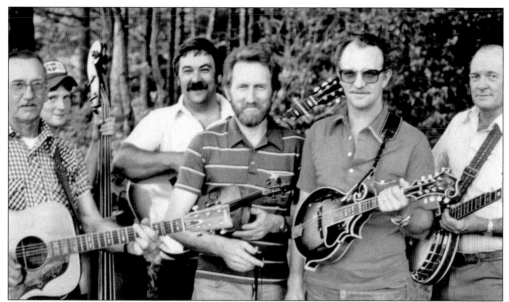

Pictured is Wade Petty (fiddle) with friends Jay Burris (guitar at left), Joey Burris (bass), Ronny Gravley (guitar in back), Jack Handy (mandolin), and Earl Burris (banjo). Wade was one of the early fiddlers for Big Country Bluegrass. He won first place at the Old Fiddlers' Convention playing "Monroe Blues" in 1980. He lends his talents to any group to encourage them and plays now with a variety of bands. He can be found fiddling anywhere from Sparta to Claytor Lake. (Courtesy of Wade Petty.)

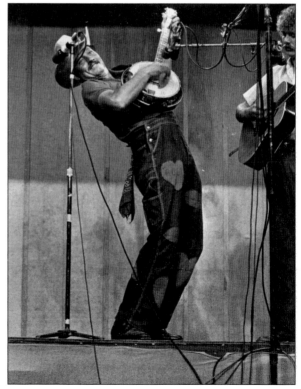

Shown here is Buck Perry of the New River Ramblers, which included two of his brothers. They were known for putting on quite a show. He pleased the crowd with his showmanship, as this picture depicts. They placed third in 1973 and first in 1974 at the Old Fiddlers' Convention, with Buck winning the same both years in banjo. It is rumored that they would tune up a half step to get the edge on the competition. (Courtesy Mark Sanderford.)

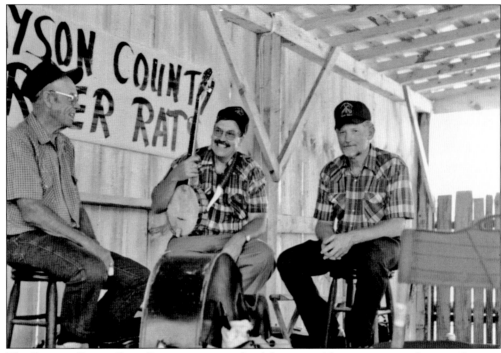

The Grayson County River Rats are an example of the many old-time groups in Grayson County. From left to right are Earl Burris, Roger Wilson, and John Perry.

John Warren grew up in Rugby, Virginia, and has been around old-time music all his life. His love of the music prompted him to play the clawhammer banjo. He is as old-time as it gets. He also has been a flatfoot dancer, a local form of dance, for over 70 years.

Two

CITY OF GALAX

Galax, best known in stringed music for the annual Old Fiddlers' Convention, has a history rich in contributions to traditional music. It was in Galax that the Hill Billies got together. They were the first band to have commercial success at the birth of country music. They were the first string band to appear in a movie and to perform for a president and also the first to do extensive touring. Many fine musicians followed in their footsteps. The Edmonds family lived in Galax, with the Lundy family nearby. There were fiddler's competitions before the Galax Fiddler's Convention, but a special magic seems to have made the Galax competition grow into the biggest and best, still going strong after 72 years. In 1935, the Moose Lodge, looking for a way to raise money, decided to give cash prizes at a stringed music event. In order to have a place to house the contest, the Moose used the schoolhouse for this first event. The first convention played to an overflow crowd with people being turned away. Since then, it has expanded to a weeklong affair. Categories have been added with the banjo, fiddle, and band competitions to include old time and bluegrass. A grandstand has been built and rebuilt to accommodate the increasing crowds. People come from all over the country and the world, with prize money growing from $132.50 in 1940 to $20,000 in cash prizes and ribbons in 2006. In 1962, Lisa Chiera of Baltimore and Michael Seeger of Roosevelt, New Jersey, recorded the event for Folkways. NBC filmed the Old Fiddlers Convention in 1966 with 25,000 in attendance. The convention continues to delight the many people who come to it and is a wonderful ongoing celebration of the music that was born in these parts.

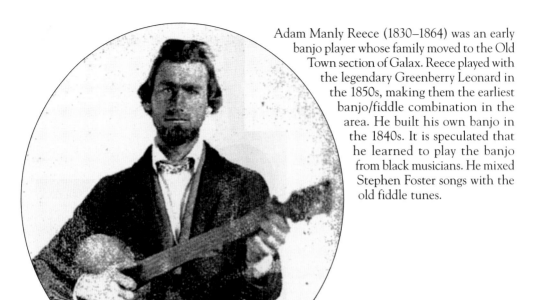

Adam Manly Reece (1830–1864) was an early banjo player whose family moved to the Old Town section of Galax. Reece played with the legendary Greenberry Leonard in the 1850s, making them the earliest banjo/fiddle combination in the area. He built his own banjo in the 1840s. It is speculated that he learned to play the banjo from black musicians. He mixed Stephen Foster songs with the old fiddle tunes.

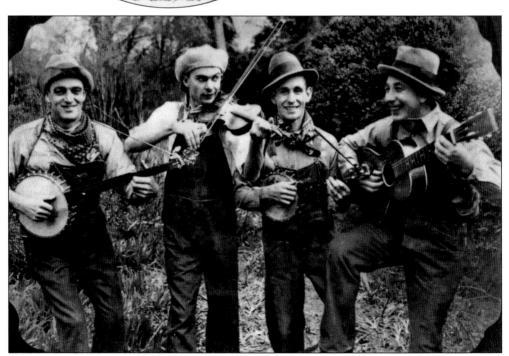

The original Hill Billies traveled to New York City and recorded between 1926 and 1928. Eleanor Roosevelt saw them at the Whitetop Festival in the 1930s and invited them to the White House to play. From left to right are Charlie Bowman, Elvis Alderman (whose father helped organize the Galax Fiddler's Convention), John Hopkins, and Al Hopkins. Orlus Nester also played with them. The band broke up when Al Hopkins died in a car accident. (Courtesy John Coffey.)

Dr. Whitefield Davis (1889–1956) was one of the first men who started the Old Fiddlers Convention in April 1935. He was part of the Bogtrotters, who won that first band contest. Dr. Davis was an important part of the community as a doctor, musician, and fiddle player. He inspired Whit Sizemore (his namesake), both as a fiddler and a builder of fiddles. Whit owns Dr. Davis's fiddle. (Courtesy Mark Sanderford.)

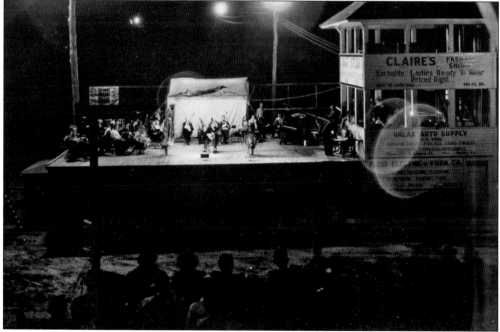

The first Old Fiddlers Convention of Galax was held in the schoolhouse April 12, 1935, with an overflow crowd. A two-day convention was held in October 1935 with 1,300 in attendance. By August 18 and 19, 1939, the convention was being held in Felts Park, pictured above. Among the winners that year were Estell and Orna Ball, mentors of Wayne Henderson. Elizabeth Osborne took first place in banjo. (Courtesy Mark Sanderford.)

SPONSORED BY MOOSE AND P-T. A.

OLD FIDDLERS' CONVENTION

ANDREWS-De HAVEN SHOE STORE

GALAX — Shoes Expertly Fitted By X-Ray — VIRGINIA

SEVENTH ANNUAL EVENT - - - - - - - **FELTS PARK**

In Event Of Rain Will Be Held In High School Building

GALAX, VIRGINIA
FRI. & SAT. AUG. 9-10

STARTING AT 7:30 O'CLOCK EACH NIGHT

$132.⁵⁰ In Cash Prizes

ADMISSION, 15c and 25c GRAND STAND SEATS 10c EXTRA

Shown here is a copy of a poster advertising the sixth annual Old Fiddler's Convention in 1940. Many of the local businesses advertised on the poster. It also listed the prizes to be awarded. There were seven categories with a total of $132 in prize money awarded, compared to $20,000 in prize money at the 71st convention. (Courtesy Galax Moose Lodge.)

34

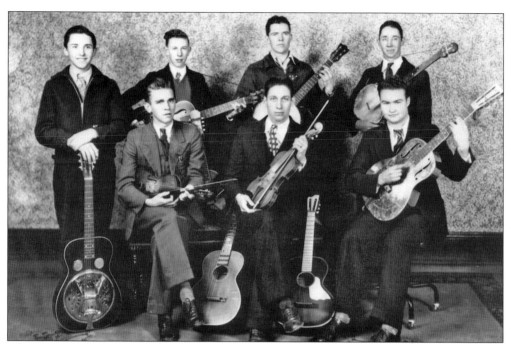

Clinton Farmer's band from Woodlawn competed in the first Old Fiddlers' Convention. They were all dressed up and looked very professional. Clinton moved to West Virginia and joined the West Virginia Nighthawks. They won first place in the band competition in 1940, with Clinton placing fifth in the fiddle competition. Clinton moved to California but came back to compete in 1969. He found the festival had grown a lot.

George Stoneman, an Old Fiddlers' Convention regular since the beginning, lived in Galax and played often with his cousin, Pop Stoneman. In the 1920s, he played with the Blue Ridge Corn Shuckers and recorded with Alan Lomax for a Prestige album. He had a great Gibson banjo, which his son now has. He placed or won from 1939 through 1962, even after the competition was split into clawhammer and bluegrass styles in 1963. (Courtesy Mark Sanderford.)

Pictured in 1944, Charlie Higgins (1887–1967), called the "King of Fiddlers" by some, started playing the fiddle at the age of seven after his father gave him one. Charlie got help from his neighbor Emmett Lundy, whose fiddle playing continues to be legendary in old-time music. In 1941, "Uncle Charlie" participated in the Eighth Annual Folk Festival in Washington, D.C. Charlie placed first in the fiddle competition at the Old Fiddlers' Convention in 1946. (Courtesy Mark Sanderford.)

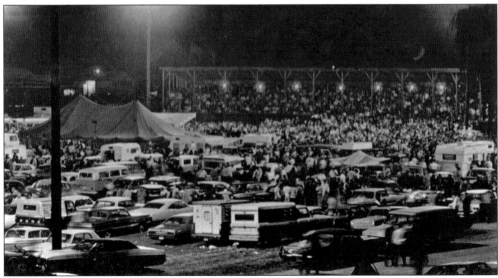

The Old Fiddlers' Convention continues to be held at Felts Park. The grandstand and stage shown in the previous picture, taken in 1944, burned down in 1945. The next year, new wooden bleachers, shown in this picture, were built to accommodate the crowds. The stage can be seen in front of the big tent. The large tent was where the contestants gathered before they went on stage. (Courtesy Oscar and Larmine Hall.)

Pictured here are the Blue Sky Ramblers at the 1993 Old Fiddlers' Convention. From left to right are (seated) Ivery Kimble, Taylor Kimble's daughter; (standing) John Coffey (fiddle), Melvin Felts (banjo), and Dea Felts (bass). This group represents approximately two centuries of music expertise. (Courtesy Heritage Records.)

Shown here is Leake Caudle (fiddle) who started competing in the Old Fiddlers' Convention in 1946. His bands have scored high for many years. He can be heard on the Rounder album *Old Times, New Times* with Esker Hutchens (fiddle) and Benton Flippin (banjo). Leake is backing them up on guitar as they play "Eighth of January" and "Raggedy Ann." The album is from a WPAQ broadcast 50 years ago. (Courtesy Mark Sanderford.)

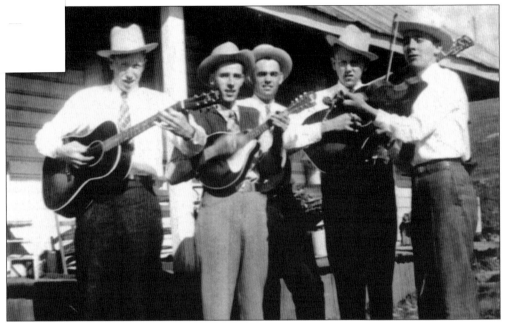

Here are the Blue Ridge Mountain Boys, who won first place in the band competition at the 1949 Old Fiddlers' Convention playing "Back Up and Push." Omer Lowe on guitar is on the left with Iver Melton (mandolin), Leonard Lowe (banjo), Thurmond Galyean (guitar), and Hurley Wilson (fiddle).

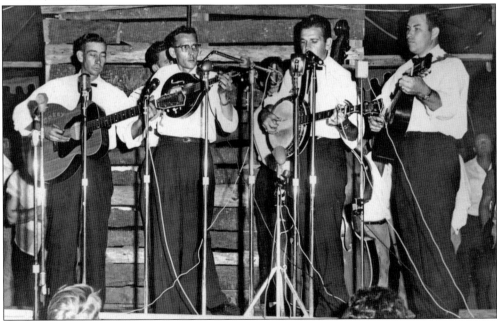

The Blue Ridge Buddies, Bobby Harrison's band, came in first at the 1954 Old Fiddlers' Convention playing "Little Star and Fortune." From left to right are (first row) Bobby Harrison on guitar, Iver Melton on mandolin, Cullen Galyean on banjo, and Julius Bartley on guitar; (second row, hidden from view) Talmadge Smith on fiddle and Aldine Lineberry on bass. (Courtesy Mark Sanderford.)

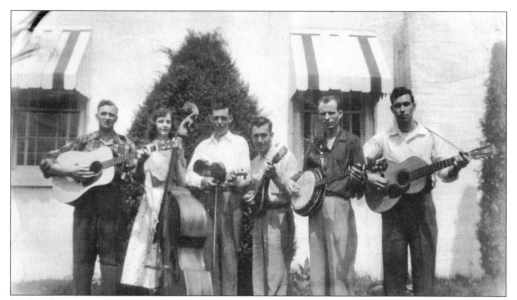

Radio played a very important role in the growth of bluegrass music in the area. Just before going on the air live at WBOB in Galax, these musicians posed for a photograph in front of the station in the early 1950s. They are, from left to right, Kenneth Edwards (guitar), Katie Lundy (Golden) with her bass, Junior Wooten (fiddle), Carroll Harrison (mandolin), Artie Coleman (banjo), and Bobby Harrison (guitar). (Courtesy Dr. Ronnie Harrison.)

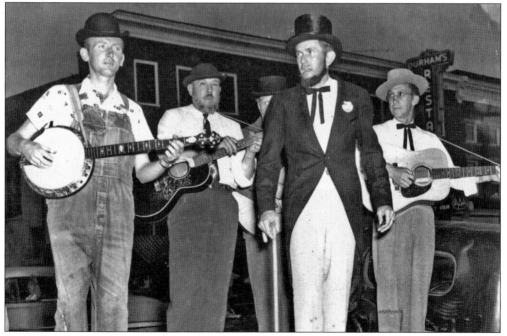

Music was woven into everyday life in Galax as well as being a big part of special occasions. The leaders of the town are shown on Main Street during the festivities of the 50th Year Celebration in 1956. Larry Richardson (left) once played with Bill Monroe and won a contest against Earl Scruggs. On guitar at left is Smiley Davidson, Ralph Edwards is in the top hat, and Kelly Lundy is at right. (Courtesy Mark Sanderford.)

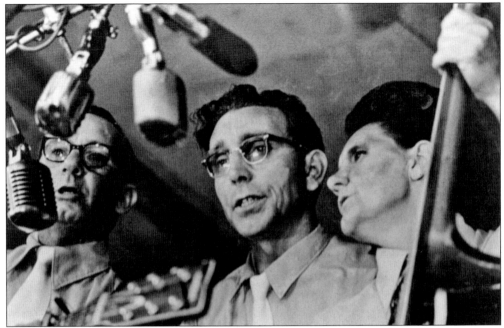

Talmadge Smith, pictured here singing, is well known for his fiddle playing with tunes like "Wild Bill Jones." Aldine Lineberry is playing the bass with Jay Burris on guitar. Jay is also a good dancer and the uncle to James Burris, who plays fiddle with Southern Pride. Joey Burris, his brother, plays clawhammer banjo, showing how the music is passed on in a family.

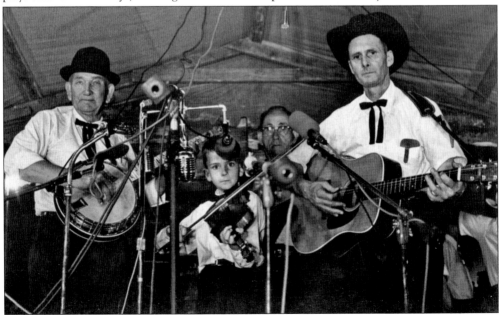

Pictured here is the Buck Mountain Band—Dale Poe (guitar), Wade Ward (banjo), Jimmy Edmonds (fiddle), and Clyde Isaacs (mandolin). Often entertaining crowds at Parson's Auction Company sales, they played at Fisher's Peak when Parson's was auctioning it and the city purchased it in the early 1970s. That day was cold and windy; Wade died that night. His banjo was taken per his request to the Smithsonian. (Courtesy Mark Sanderford.)

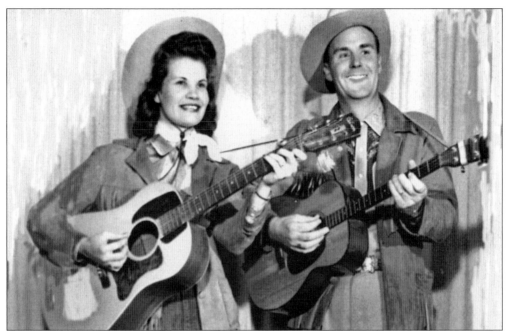

Maude Smith Lowe ("Aunt Martha") and her husband, Toby, grew up in Galax, Virginia. She and Toby played in the 1960s with the well-known Dixie Ramblers. The Ramblers included Wilson Ramey (fiddle), Olen Gardner (banjo), and Marie Gallimore (bass). The band won first prize at Ocean Grove in 1957. In 1968, Toby won the fiddle prize. (Courtesy Maude Lowe.)

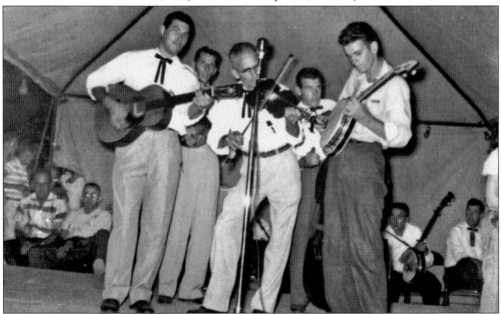

Shown in 1957 is an early version of a band that would be a high-profile group for over three decades. Known as the Blue Ridge Buddies, the Virginia Mountain Boys, and the Foothill Boys, the group was made up of the core trio of Bobby Harrison (guitar), Cullen Galyean (banjo), and Iver Melton (mandolin), pictured here with Glenn Neaves (fiddle) and Warren Brown (bass) at the Fiddlers Convention. (Courtesy Mark Sanderford.)

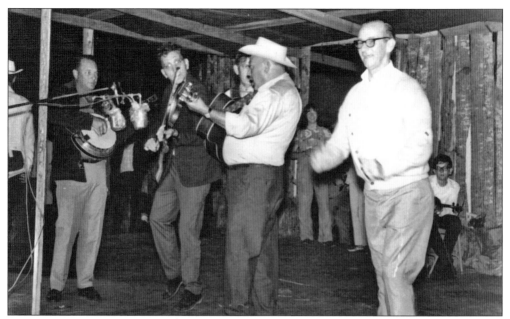

Here is an early Old Fiddlers' Convention shot with Talmadge Smith on the fiddle, Earl Burris on banjo, an unidentified dancer, and Jimmy Edmonds looking on. Tom Norman speaks well of Talmadge Smith. He enjoyed playing with him, especially how he played "Wild Bill Jones." Earl Burris is Otis Burris's son. The Burris family has a long history playing music around Galax and Pipers Gap. (Courtesy Mark Sanderford.)

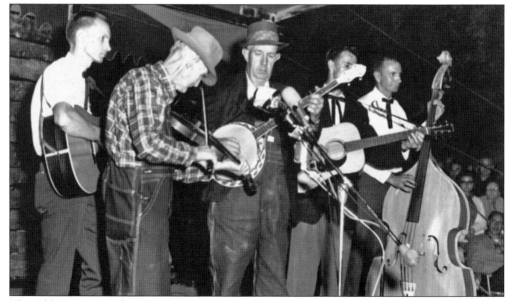

The Old Timers Band, pictured from left to right, is John Edmonds; his father, Norm Edmonds; Ruth "Rufus" Quesinberry; Cecil Edmonds (also Norm's son) on guitar; and Harry Edmonds (Jimmy's dad). This Edmonds family band won fourth prize in the 1964 Old Fiddlers' Convention. Norm plays one of his father's favorite tunes, "Walking in the Parlor," on the Galax album recorded by Folkways. Norm's father was said to have learned on a corn-stalk fiddle. (Courtesy Mark Sanderford.)

Dale Poe lived in Independence in Grayson County. He did well in the folk song competition, with second place in 1966 and first place in 1968. The 1964 *Galax, Virginia, Old Fiddlers Convention* Folkways record has Dale playing "Blackberry Blossom" with Wade Ward (1873–1964) and Charlie Higgins (1876–1967). They also played together at auction sales where Luther Davis was the auctioneer. (Courtesy Mark Sanderford.)

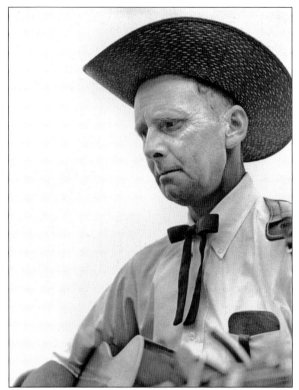

Here is a folksong competition in the early 1970s with Larry Pennington (banjo) and Herb Key (guitar), with Harold Mitchell holding the clipboard. Harold served for many years as an announcer for the convention as well as hosting a live radio show on WBOB. He has been emceeing conventions and shows throughout most of his career. He has worked with many legends of bluegrass music and has many a story to tell. (Courtesy Mark Sanderford.)

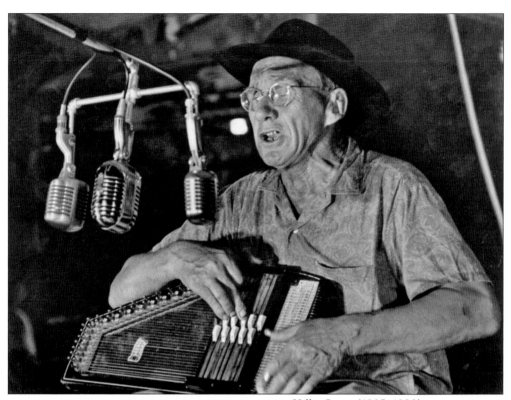

Kilby Snow (1905–1980), an outstanding autoharp player, won the title of autoharp champion of North Carolina before he was six years old. He was left-handed and modified his autoharps to suit his upside-down, backward style. He played at the Newport Folk Festival and has recorded a number of tunes, including original gospel and traditional tunes like "Ella's Grave." The Grateful Dead's Jerry Garcia was drawn to Kilby's music. (Courtesy Mark Sanderford.)

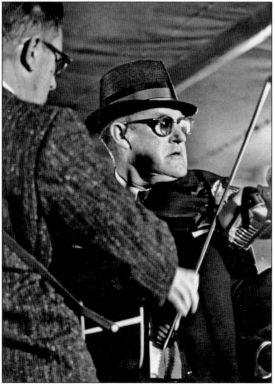

Fred Cockerham (1905–1980) was from the Lambsburg area and was often part of the Old Fiddlers' Convention. He is on at least nine records playing tunes like "Carroll County Blues." He played often with Tommy Jarrell, who was from Mount Airy. Tommy on the fiddle and Fred on the fretless banjo made music like the old-time music played at house dances after a hard day's work. (Courtesy Mark Sanderford.)

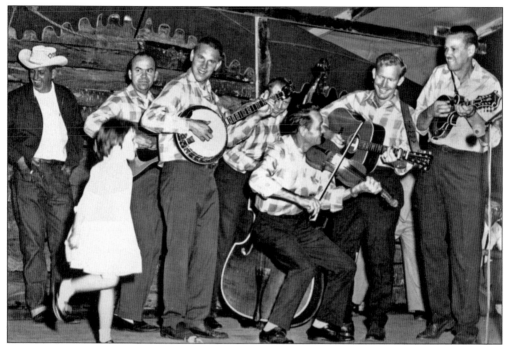

Pictured is a young girl dancing to James Lindsey and the Mountain Ramblers, a local Galax band in the 1960s with Otis Burris (fiddle), James Lindsey (mandolin), Willard Gayheart (guitar at left), Thurman Pugh (bass), and Jimmy Zeh (banjo). The man with the cowboy hat is Moose member Bill Martin. Jim McKinnon (guitar) is second from right. They were winners at several conventions including Galax. (Courtesy Mark Sanderford.)

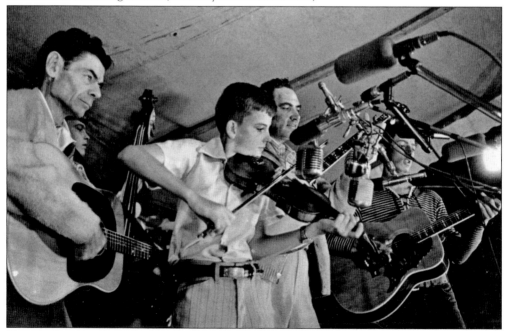

Here are Jimmy Edmonds on fiddle, Olen Gardner on banjo, Wade Gardner on guitar at right, and Jack Reddick on guitar at left. (Courtesy Mark Sanderford.)

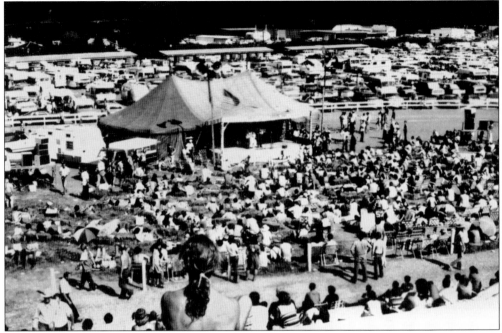

People from far and wide came to hear the good old music at the Old Fiddlers' Convention, from all over the United States as well as Australia, England, and Japan. In front of the grandstand, people set up chairs and cheer on their favorite competitors. While the competition is going on, many people stay in the camping areas listening to groups practicing or jamming. (Courtesy Bobby Patterson.)

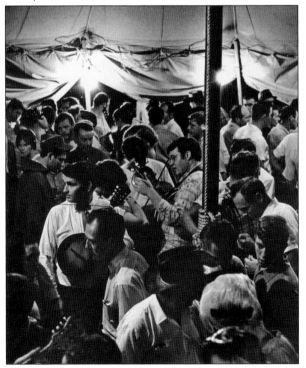

Pictured here are contestants inside the big tent preparing to compete. Even today, contestants line up through and beyond the tent, with often more than 100 competing in each category. The first convention had 10 categories. These have changed over the years with additions and omissions. There no longer is a square dance category, but bluegrass categories have been added as well as prize ribbons for youth competitors.

Eunice Cole said, "My Tub Bass and I first met at Union Grove, NC. From then on, it was ON. I rigged up my own tub bass and we made appearances at Union Grove and at Independence, Virginia's Fourth of July Celebration. We met Will Keys and played at Norris, Tennessee for 6 years. Retiring for quite a few years, we are now being brought out of retirement for better or for worse." (Courtesy Eunice Cole.)

Seen here is Olen Gardner, who hails from Carroll County. He still judges competitions from time to time. He is a wonderful craftsman and a musician, building and repairing instruments. He once owned one of Charlie Poole's banjos but had to pawn it. The pawn shop owner promised he would hold it for him but sold it before Olen could buy it back. He has been looking for it ever since.

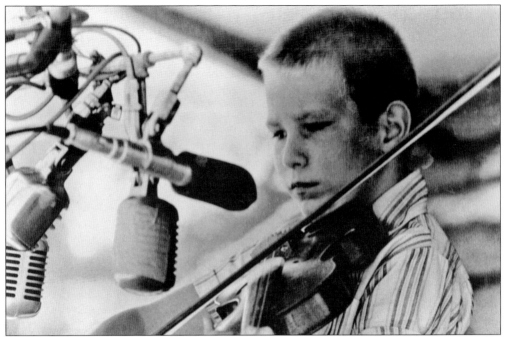

T. J. Lundy is performing here at the Old Fiddlers' Convention. The Lundy name looms large in the musical history of the area. Emmett Lundy (1864–1953) was recorded in 1941 for the Library of Congress. In a line of descent through cousins of Emmett are Katie and Ted Lundy. Ted's band, the Southern Mountain Boys Bluegrass Band, won repeatedly at the Old Fiddlers' Convention. A Heritage recording, *Back in Galax Again*, features five Lundys. (Courtesy Mark Sanderford.)

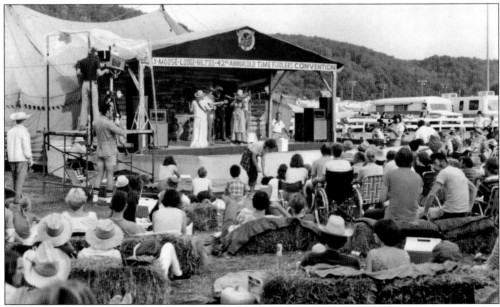

In 1977, a more permanent stage area was built, which can be seen in this picture. On this new stage, the sign across the top tells that this was the 42nd Old Time Fiddlers Convention. This sign is updated at each subsequent convention, so it serves as a good way to keep track of when the pictures are taken. (Courtesy Mark Sanderford.)

Pictured here is Jimmy Vipperman. His father, John Vipperman, replaced Carter Stanley in Bill Monroe's band in the fall of 1951. John was supposed to play banjo but instead played guitar. John also worked with the Sons of the Pioneers while in the army. He married Flossie Quesenberry in 1954 and had Jimmy, Larry, and Alisha. Jimmy has won many awards for his music at a variety of gatherings. (Courtesy Mark Sanderford.)

Herman Winesett and his wife, Sena, were born and raised in Galax. He worked in the furniture factory. They had no children of their own, but Herman always had a surprise piece of gum for any visiting them. He loved music and played the Jew's harp, spoons, guitar, and harmonica, often entertaining by playing two harmonicas at once. He taught three generations of nieces and nephews to play. (Courtesy Galax Moose Lodge.)

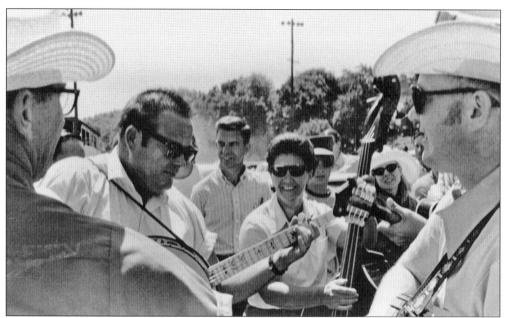

Pictured is a jam with Charles Hawks on the banjo (left), Aldine Lineberry on bass, Wayne Houser on banjo, and Jay Burris on guitar. Aldine played on a number of recordings, including "June Apple" on Heritage Records with Tommy and Kyle Creed and Bobby Patterson and *Old-Time Music from the Blue Ridge Mountains* with Whit and Mike Davis, Dan Williams, and Tom Norman. Aldine played with Charlie Monroe and is an outstanding songwriter. (Courtesy Mark Sanderford.)

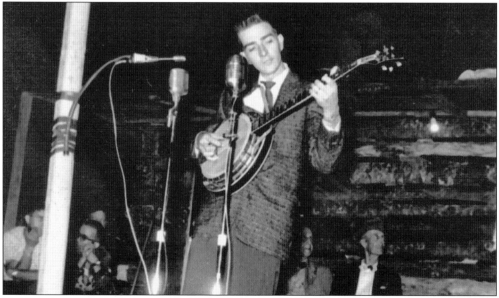

Ted Lundy (1937–1980) from Galax belonged to one of the area's musical families and began with guitar at age eight before switching to Scruggs-style banjo at 14. He played on the radio as a teenager with the Shady Valley Boys. He started the Southern Mountain Boys with Bob Paisley, Fred Hannah, and Jerry Lundy, winning numerous times at the Old Fiddlers' Convention. T. J., Bobby Lundy, and Dan Paisley are second-generation Southern Mountain Boys. (Courtesy Galax Moose Lodge.)

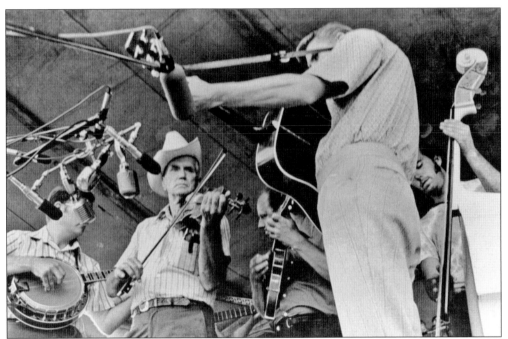

Pictured here are the Camp Creek Boys. Kyle Creed (1912–1982) is playing the fiddle. He learned to play banjo from his uncle. During the 1960s, he started building banjos with the help of Pearly Bryant, his neighbor. Also in the picture are Bobby Patterson on banjo (of Heritage Records), David Freeman on mandolin (of Rebel Records), and Pete Lissman on guitar. (Courtesy Mark Sanderford.)

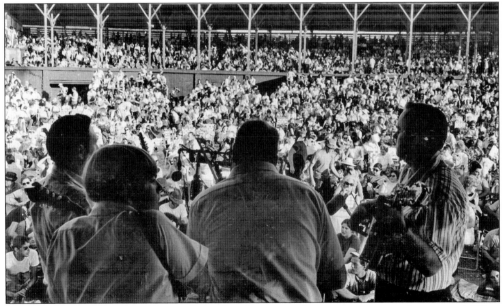

The Shady Mountain Ramblers, a Galax band, are seen here entertaining a huge crowd. They are, from left to right, Dan Williams (guitar); Mike Sizemore (mandolin); his father, Whitfield Sizemore (fiddle); and Billy Rippey (banjo). They placed sixth in the Old Time Band competition in 1972 and fourth in 1973 and 1974. (Courtesy Mark Sanderford.)

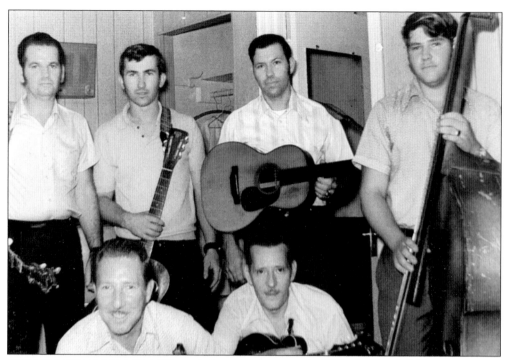

In 1972, the Foothill Boys were invited to perform on WSM's Grand Ole Opry in Nashville, Tennessee. Shown here during a practice session in Nashville are, from left to right, (seated) Herman Dalton (fiddle) and Iver Melton (mandolin); (standing) Cullen Galyean (banjo), Roy Bourne (dobro), Bobby Harrison (guitar), and Roger Dalton (bass). The tight harmony vocals of Cullen, Bobby, and Iver were a trademark of this stellar group. (Courtesy Galax Moose Lodge.)

Wesley Golding, seen here competing at the Old Fiddlers' Convention, grew up in Cana about a mile from James King and wrote the song "Going Back to Cana." He played with a number of bands, including Boone Creek (with Ricky Scaggs). When he was about six, he played with the Playmates, which included Jimmy Edmonds, Jimmy Arnold (banjo), Larry Lindsay (guitar), and Terry Montgomery (bass). (Courtesy Mark Sanderford.)

Clarence and Bobbi Roberts are old-time musicians. Clarence plays the fiddle, guitar, dulcimer, and dobro, and Bobbi plays the old-time banjo and autoharp. Clarence is also a songwriter and luthier who has built fiddles, guitars, dobros, dulcimers, and the autoharps Bobbi plays. They enjoy attending all the fiddler's conventions in the area and playing shows and dances. (Courtesy Clarence and Bobbi Roberts.)

Joe Edd King was a wonderful fiddler from Cana and thought to be related to James King. Here he is competing in a fiddler's convention at Stuart. On the way back from the convention, he was tragically killed in an auto wreck. He won first place at the Old Fiddlers' Convention in 1973. (Courtesy Mark Sanderford.)

Pictured are "Uncle Norm" Edmonds and his grandson Jimmy Edmonds. Jimmy at age four would watch his grandpa play. One day, he came to the breakfast table playing "Bile Them Cabbage Down." He was five when he competed before 8,500 people. At age six, he won Best Performer at the Lester Flatt Bluegrass Festival. That same year, at the 30th Galax Fiddlers Convention on August 19, 1965, he was awarded Best All-Around Individual Performer. (Courtesy Vera Edmonds.)

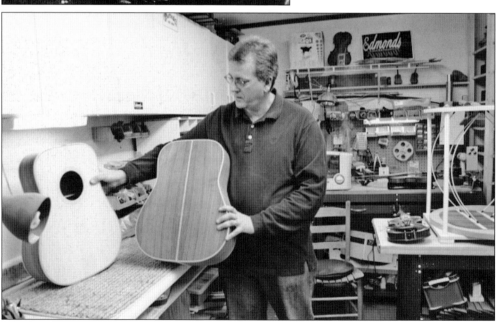

Besides being a world-class fiddler, Jimmy Edmonds is also a highly respected luthier with a long list of customers waiting to own one of his guitars or fiddles. Here he is seen in his shop in Carroll County holding the bodies of two dreadnoughts he is making. They are for two brothers, so Jimmy is using sister cuts of rosewood to make them as close to identical as possible. (Courtesy Ben Anderson.)

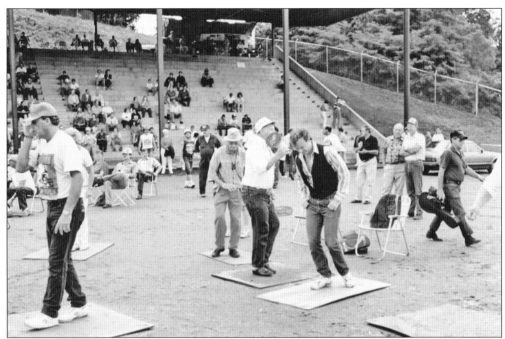

In 1972, new concrete bleachers were built, seen in the background of this photograph. In the foreground, dancers practice. They have boards they are flat-footing on. This helps to get good footing when the ground is muddy and also helps the audience hear the beat they are making. They take their boards with them and go around to the jams and dance. (Courtesy Galax Moose Lodge.)

Here is an aerial view of the convention taken around 1974. The concrete grandstand and the big tent can be seen, as well as the big crowd the convention attracted. In 1974, the estimate of the crowd was 30,000, with bands competing from Japan and Sweden. With so many people there, it is no surprise that politicians would be there, too—senators and congressmen shaking hands. (Courtesy Galax Moose Lodge.)

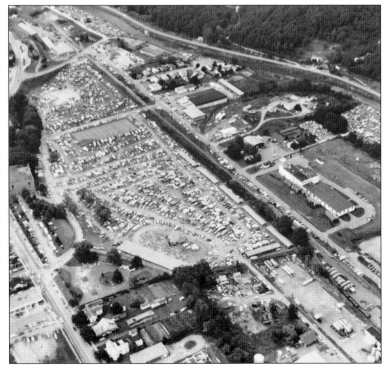

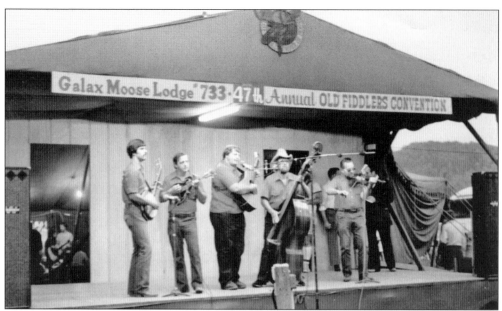

The Southeast Grass, led by guitarist Danny Boyd of Hillsville, consisted of Ronny Harrison (banjo), Ronnie Lyons (mandolin), Clifton Phillips (bass), and Johnny Miller (fiddle). They are shown here at the Galax Fiddlers Convention in 1982. As one of the more prolific award-winning groups in the 1980s, they were known for their high-energy instrumentals and tight harmony singing. (Courtesy Galax Moose Lodge.)

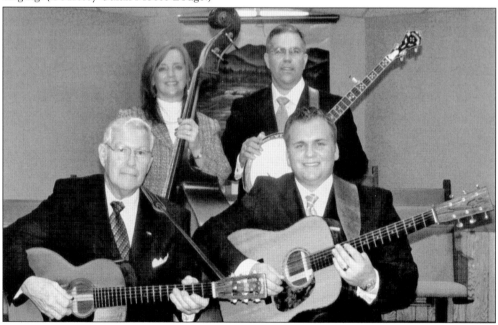

Family tradition plays an important role in the preservation of this music. The Harrison family illustrates this with three generations side-by-side as they perform for a service at Landmark Baptist Church in Galax in January 2008. Legendary guitarist and vocalist Bobby Harrison is joined by his son, Dr. Ronny Harrison, on banjo, also the pastor of the church. Ronny's wife, Donita (Boyd) Harrison, plays bass with their son Chad on guitar. (Courtesy Dr. Ronny Harrison.)

Three

CARROLL COUNTY

Carroll County was founded in 1842 and named for Charles Carroll, a signer of the Declaration of Independence. The courthouse in Hillsville, Virginia, the county seat, is the site of the historical March 14, 1912, gun battle that came to be known as the Courthouse Tragedy, where five people were killed. Musical heritage is important to Carroll County, with the internationally known Old Fiddler's Convention held every year the second weekend in August in Galax, Virginia. Carroll County and the city of Galax are access points for the Blue Ridge Music Center, located on the Blue Ridge Parkway. The Crooked Road, Virginia's Music Heritage Trail, is a driving trail that follows U.S. 58 primarily and extends from the Blue Ridge Mountains and the Blue Ridge Music Center through Bristol and the coalfields. The trail runs along Route 221 in Floyd and Carroll Counties and continues on U.S. 58. This section of southwestern Virginia is blessed with an abundance of historic and contemporary music venues, musicians, and fretted instrument makers.

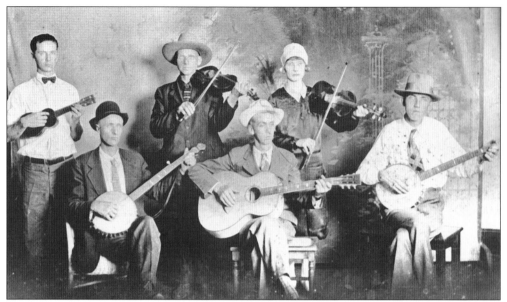

From left to right are (first row) an unidentified banjo player, Ernest Stoneman, and Bowlen Frost; (second row) Iver Melton, Uncle Eck Dunford, and Hattie Frost Stoneman. Believing he could outdo fellow Virginian Henry Whitter, Ernest "Pop" Stoneman went north to New York City in 1924 to record "The Ship That Never Returned/The Titanic" for OKEH, accompanying himself on autoharp and harmonica. Although a guitar player, he taught Tony Alderman of the Hill Billies the fiddle. (Courtesy Patsy Stoneman Murphy.)

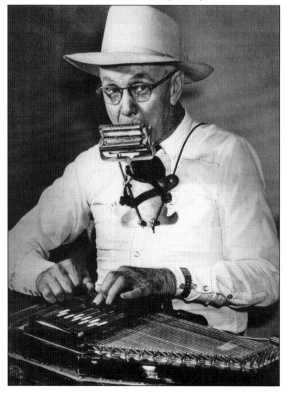

"Pop" Stoneman proved his point. His musical fortunes would run him through the 1920s. During his career, he recorded under all three technologies— cylinder, acoustical, and electrical. Stoneman was born near the mining community of Iron Ridge in Carroll County in 1893. He met his future wife, Hattie Frost, in nearby Galax and began the traditional, seven-year mountain courtship before marrying, walking 5 miles to and from her home. (Courtesy Patsy Stoneman Murphy.)

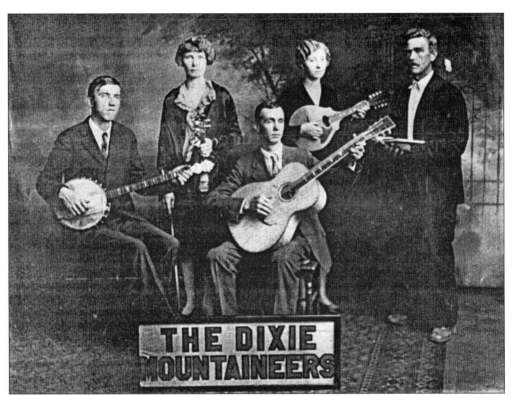

From left to right are (seated) Bowlen Frost (banjo) and Pop Stoneman (guitar); (standing) Hattie Frost (fiddle), unidentified (mandolin) and unidentified (fiddle). Pop Stoneman convinced Victor talent scout Ralph Peer to come to Bristol, Tennessee, to audition local talent. In July and August 1927, Stoneman helped Peer conduct the legendary Bristol sessions, which introduced the world to Jimmie Rodgers and the Carter Family. Peer continued to be active in recording through 1929. (Courtesy Heritage Records.)

When Pop married Hattie Frost in November 1918, he entered another musically involved family. Hattie Frost Stoneman was regarded by the Library of Congress to be the first woman of importance in country music. Falling on hard times during the Depression, the Stonemans and their nine surviving children moved to the Washington, D.C., area in 1932 after losing their home and most of their possessions. (Courtesy Heritage Records.)

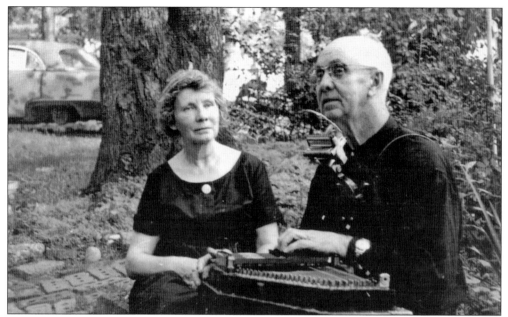

Pictured here are Hattie and Pop Stoneman. The demand for the Stonemans' records was so great that at one time, he recorded under 18 different names for eight different labels, until the chaotic recording scene of that era was clarified by new legal regulations. The children soon joined their musical parents and formed a group. Of the 23 children born to the Stonemans, only 13 lived to adulthood. (Courtesy Patsy Stoneman Murphy.)

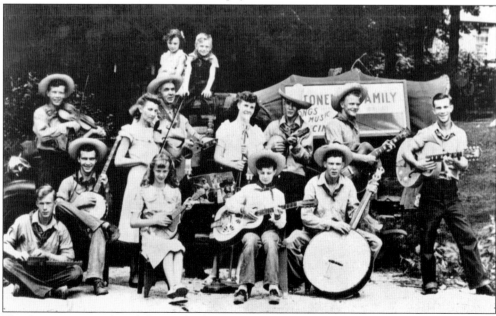

The Stonemans are, from left to right, (first row) John, Bill, Donna, Jim, and Jack; (second row) Scott, Hattie, Ernest "Pop," Grace, Dean, Gene, and Eddie; (third row) Roni and Van (not pictured is Patsy). Pop was fond of telling how he got the youngsters started on their instruments. He would tune an instrument, lay it on the bed, and order the kids to leave it alone. Soon, to his delight, they were doing just the opposite. (Courtesy Patsy Stoneman Murphy.)

In 1966, the Stonemans moved to Nashville and found immediate acceptance. In fact, they took the town by storm. Within two months, they were signed to a contract for their own syndicated color television show and a recording contract with MGM Records. As a result of the debut of their television show and their records, demand for personal appearances increased. Within the next two years, the group—including Pop—was maintaining an exhausting road and travel schedule that kept them away from home 75–80 percent of the time. Patsy, a daughter who idolized her father and his music, joined the group a week after Pop's death (April 16, 1668). She loves and specializes in the old music of her father. Her participation has thus ensured the continued adherence to the Ernest Stoneman traditions. (Courtesy Patsy Stoneman Murphy.)

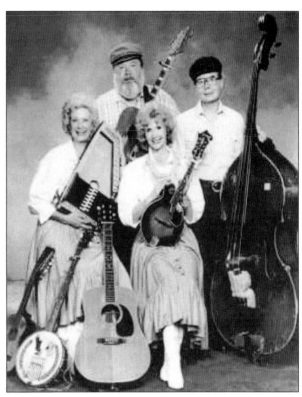

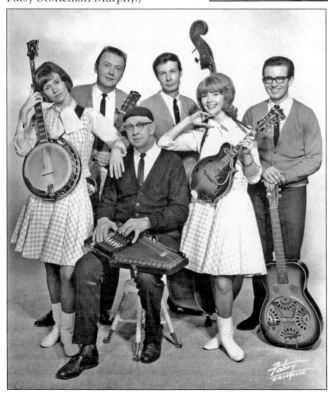

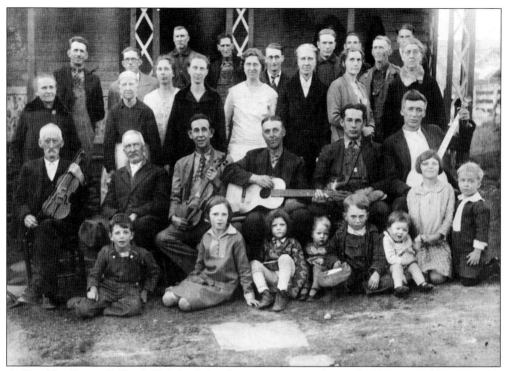

At Franklin Pierce Collins's 74th birthday, he was entertained in style. He is seated between the two fiddle players. Pictured here on the left is Fielding Lowe (1860–1953). His family, who lived near Pipers Gap for 200 years or so, was very musical. Fielding loved to play "Do You Want to Go to Heaven, Uncle Joe?" On the right is Charlie Higgins (1878–1967). Charlie has become legendary at the Old Fiddlers Convention and is called by some the "King of the Fiddlers." (Courtesy Wade Petty.)

Pictured from left to right are Bob Crawford (1869–1935), holding Olin Crawford, and Bob's family—Preston, Francis, Ethel, and Stella. Bob, according to John Patterson (his nephew and Bobby Patterson's father) was one of the best fiddlers ever. He was influenced by Greenberry Leonard and Emmett Lundy, who were responsible for what has come to be called the "Galax Sound." Bob won first place long ago at an Oakland School Convention. (Courtesy Bobby Patterson.)

Sam Robert Fortner (1839–c. 1935) was "one of the nicest dancers you have ever seen. . . . Sam could play any kind of music," said Walter Wilson. Sam played in the clawhammer style and could make it talk. Sam played "Sally Ann," "Ground Hog," and "Little Brown Jug." He played well into his 90s and was one of the players John Patterson learned from. (Courtesy Bobby Patterson.)

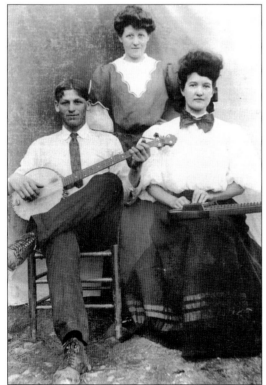

This picture, taken around 1910, shows Martin "Moten" Harrison Dickerson (banjo), Grace Angeline Burnett Dickerson (autoharp), and Bessie Burnett. The three would play and sing together. Moten and Gracie had eight children and passed their musical abilities onto them. Gracie also played the pump organ. (Courtesy Steve Mitchell.)

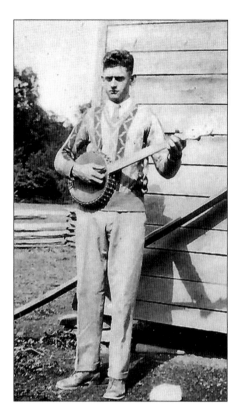

Pictured here is Kyle Dalton of Dugspur, Virginia, playing his clawhammer banjo in the 1930s. His family has lived in Dugspur for at least four generations. They were farmers, and more or less everyone played music. All of Kyle's sisters played. They traded instruments around because they couldn't afford one for each. (Courtesy Mary Turman.)

Pictured here are Kyle Dalton's sisters. They all played instruments but had to share, so only two of the sisters are shown playing in this picture taken about 1911. From left to right are (first row) Maude Dalton (autoharp) and Flotilla Dalton (guitar); (second row) Lurenda "Toy" Dalton and Printie Dalton. Even though the family was poor by the world's standards, they still had instruments. (Courtesy Violet Reece.)

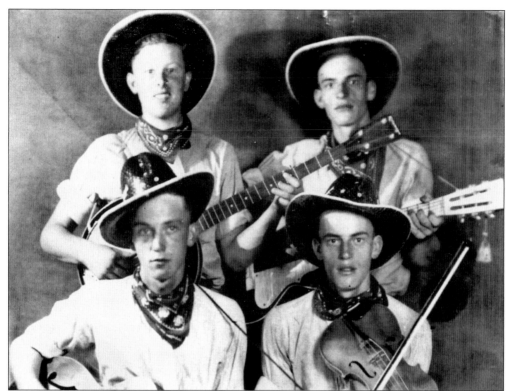

The Blue Ridge Buddies are, from left to right, (first row) Rex Willis (guitar, lead vocals) and Saford Hall (fiddle, bass vocals); (second row) Clarence Marshall, (five-string banjo, tenor vocals) and Clayton Hall (guitar, baritone vocals). In late 1934 or early 1935, the four teenagers began to play string music together. The Halls were twins and were exceptional singers and musicians. They played on WSJS Radio in Winston-Salem, North Carolina. (Courtesy Bobby Patterson.)

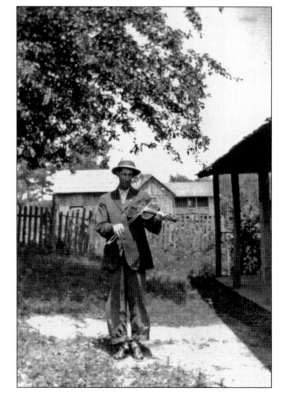

Jimmy Natural Myers (1894–1972) of Five Forks began playing fiddle at an early age, with his nephew Sidney on the banjo. Jimmy always wore a white dress shirt and jacket with a rose on the lapel. Together with neighbors Horace and Harry Spraker and Raymond Melton, they would jam into the night and played at local events, socials, pie suppers, and school functions in the 1930s and 1940s.

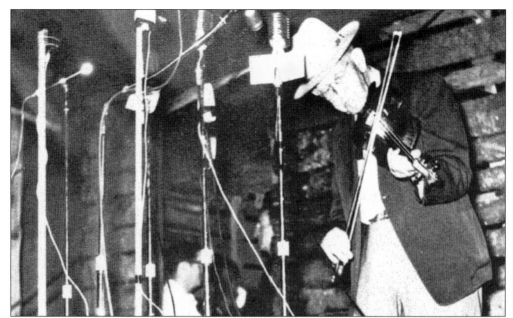

"Uncle" Charlie Higgins, pictured here at 86 in 1964, was playing his signature tune "Blackberry Blossom" at the Old Fiddlers' Convention. He can be heard on the 1964 Folkways record *Galax, Virginia, Old Fiddler's Convention* playing with Wade Ward and Dale Poe. He lived in Fairview. Jimmy Edmonds's father would take young Jimmy to learn from Uncle Charlie, who was good at explaining how to play the tunes. (Courtesy Mark Sanderford.)

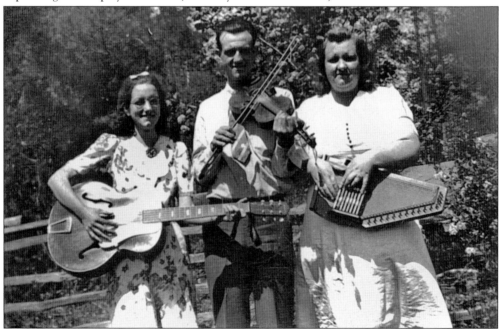

Pictured here are three members of the Norman Lee Vass family: Linnes (left), Roy, and Ruby. Their home was always a local gathering place for many musicians and those who enjoyed what has become known as "Mountain Music." Some visitors were well known. One such visitor was A. P. Carter.

In the 1950s, Elbert Marshall organized a band that played on local radio called the Carroll County Playboys. Roy Vass played the fiddle with Jim Turner on mandolin and Raymond Sutphin on banjo. Once when playing an opening performance for Bill Monroe and the Bluegrass Boys, Bill remarked to one of his band members, "That's the best playing of 'Walking in My Sleep' that I have ever heard."

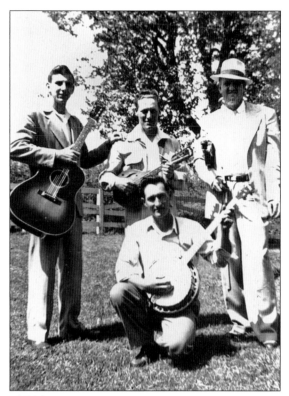

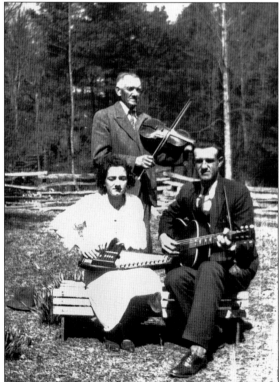

Norman Lee Vass (1876–1961) was known as one of the best fiddlers around Hillsville and Carroll County during his most active years. He is shown here with one of his daughters, Ruby (autoharp), and one of his sons, Roy (guitar), who became an accomplished musician on several instruments, especially on the fiddle and guitar.

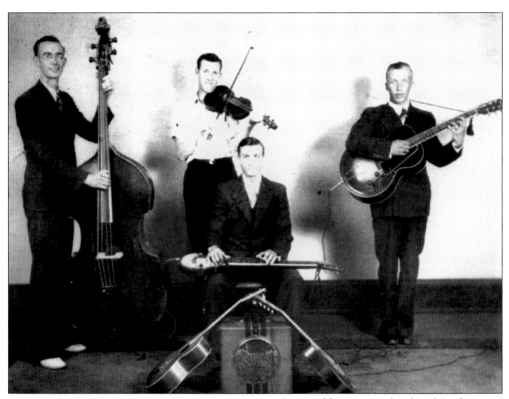

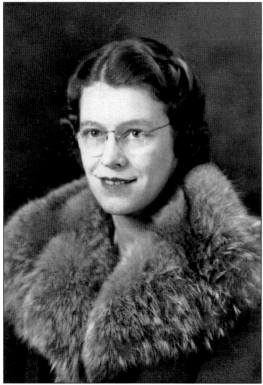

Pictured here is another band Fred Cockerham was in. This was taken in the mid-1930s and shows the beginnings of country music, with electric instruments being introduced. On the left, Slim Marion is playing the bass, and Fred Cockerham is in the center on fiddle. Lynn Vaughn plays the electrified hollow-body guitar, and Elmo Vaughn is playing an early version of the steel guitar. (Courtesy Heritage Records.)

Francis Opal McGrady Liddle, who brought music to many in the Carroll County communities of Hardscuffle, Laurel Fork, Crooked Oak, and Gladesboro, was born July 2, 1911, the eldest of John Walter and Mattie Dickerson McGrady's five children. With her family's help, she played piano, guitar, fiddle, autoharp, pump organ, and banjo. She was known for her alto singing and spirited flat-foot dancing, entertaining family and friends. (Courtesy Sarah Liddle.)

Roscoe Parish (1897–1984) and Leone Parish (born 1902) lived near Coal Creek. The brother and sister shared music for many years. Roscoe, skilled at both the fiddle and banjo, played many tunes that were rarely heard by other musicians in the area. Leone played the organ, piano, and guitar, taught school for 35 years, and was the church organist. Her repertoire included children's songs, hymns, dance tunes, ballads, and popular songs. (Courtesy Heritage Records.)

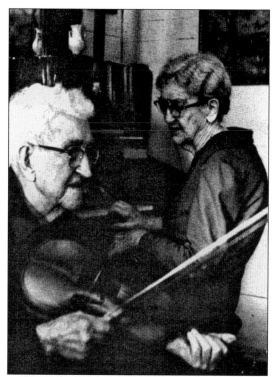

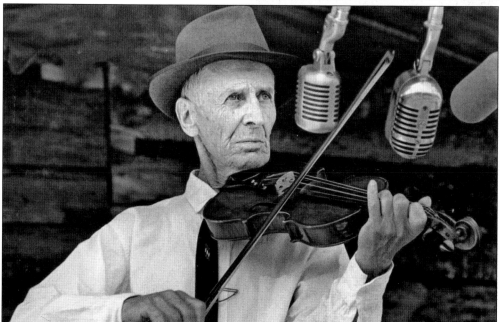

Hubert Caldwell (1894–1977), originally from Virginia, came back from Kansas in 1933. Doris Kimble called Hubert an "Irish fiddler." His fiddling didn't reflect local tunes. He played songs like "Oxbow Quadrille," "Old Virginia Waltz," and "Constitution Hornpipe." Hubert appeared at all but three of the Old Fiddlers' Conventions from 1935 until his death in 1977. He won many ribbons with his "Fisher's Hornpipe." (Courtesy Mark Sanderford.)

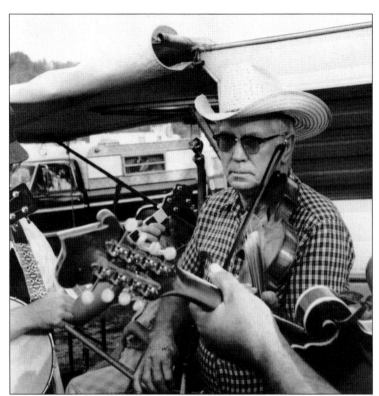

Kyle Creed (1912–1982) was a resident of Carroll County and the manager of the Camp Creek Boys. He learned his special method of banjo picking from his uncle, John Low. He began building banjos in the 1960s with the help of his neighbor, Pearly Bryant. Kyle built both bluegrass and clawhammer banjos. He has been heard at both the Galax Fiddlers Convention and the National Folk Festival. (Courtesy Bobby Patterson.)

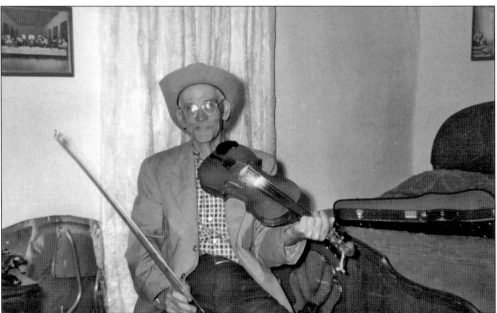

Glenn Smith (1888–1973) from Hillsville loved to play tunes like "Leather Britches" and "Fourteen Days in Georgia." Calvin Cole said of him, "That Glen Smith! He was about as good an old-time fiddler as I ever heard. He'd get about half-lit, and then he'd play real pretty." Often Norm Edmonds played fiddle while Glenn played banjo. He played "Walking in My Sleep" at the 1935 convention. (Courtesy Bobby Patterson.)

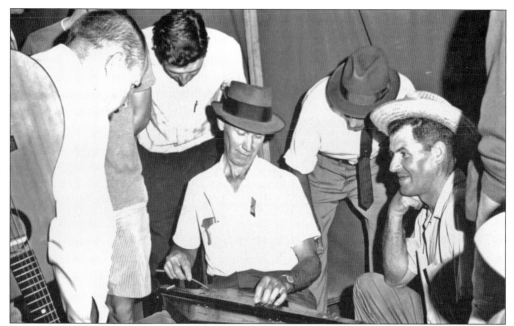

Raymond Melton (1915–1985) not only was a remarkable dulcimer builder and player, but he was also a frequent winner at the Old Fiddlers' Convention. He played at every show since the beginning, save one. He had been up late jamming, playing from 6:00 p.m. to midnight. Leaving the bathroom, he staggered because he was tired and was arrested. That was the only contest he ever missed. (Courtesy Mark Sanderford.)

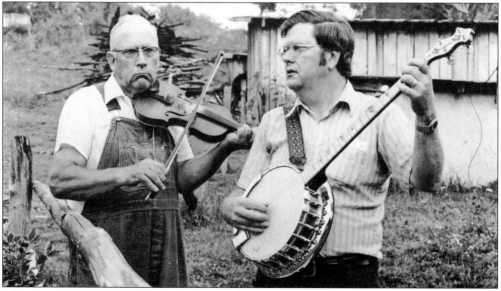

John Patterson (1904–1996) started playing the fiddle as a teenager. He learned from the best, his uncle Bob Crawford and Fielden Davis (1848–1912), who learned from Greenberry Leonard. Bobby Patterson, John's son, carried on the tradition, learning to play the guitar, banjo, and mandolin. Besides running Heritage Records, Bobby has played on many recordings, been part of the Highlanders, and as a Moose member is very involved in the Old Fiddlers' Convention. (Courtesy of Bobby Patterson.)

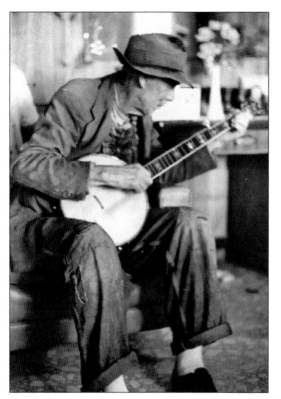

Sidney Monterville Myers (1890–1972) from the Five Forks community began playing at an early age. His nephew Fulton "Jimmy Natural" Myers played with him all his life. Sidney was very quiet and reserved, but music was a great part of his life. Every weekend, they would play well into the night. Listen to County Records No. 717, *More Clawhammer Banjo Songs and Tunes from the Mountains*, produced in 1969. (Courtesy Terry Burcham.)

T. R. Felts of Fancy Gap played clawhammer banjo at local dances with his cousin Arthur Melton, who played fiddle, and sometimes with neighbor John Rector, also a fiddler in the early 1920s. Felts continued to inspire young people with his precise rhythm and clear melodies into the 1980s. (Courtesy Melvin Felts.)

Calvin Cole (1908–1992) spent most of his life playing the banjo around Grayson and Carroll Counties. Calvin was well known for his clawhammer banjo style. His son Lonnie, one of the best bluegrass fiddlers around, was always in demand. His son Dewey and Dewey's sons, Brian and Travis, are playing and carrying on the family tradition of old-time music. (Courtesy Dewey Cole.)

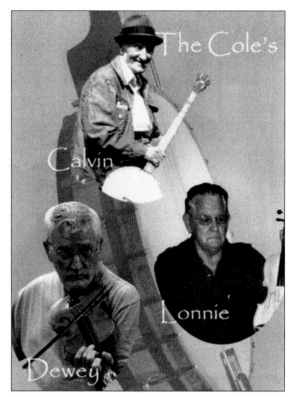

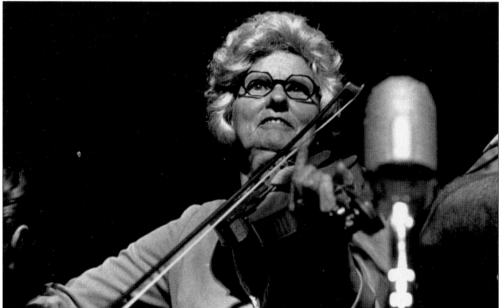

Fiddler Dorothy Quesenberry Rorrick was born in Dugspur, but because there were two Dorothys in the small town of Dugspur, she was known as "Dorothy Buck." She also played banjo, which she loved. Some said of her "she was a treasure," a great entertainer. Harry Edmonds said, "She'd put everything in it, and about to have a heart attack, wear herself out. We put on shows with her." (Courtesy Mark Sanderford.)

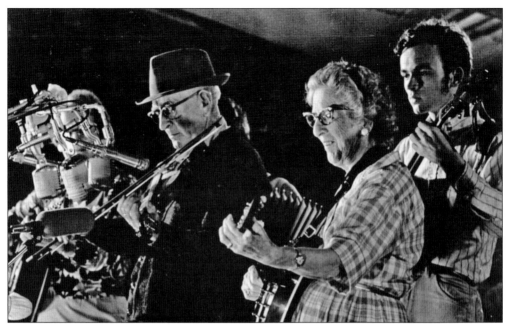

Taylor Kimble, fiddle, plays with Stella Kimble, his second wife. Taylor Kimble was one of the best-known fiddlers in eastern Carroll County. Stella learned to play the banjo at her father's knee and always played double-thumb style. Taylor's first wife, Jumillie (1894–1966), played dulcimer. (Courtesy Mark Sanderford.)

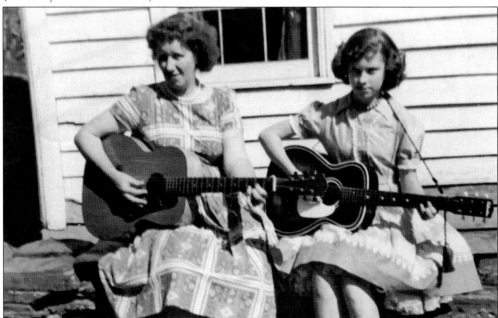

Pictured here are Phyllis Newman (right) and her aunt Virginia Cruise in 1962. Virginia taught Phyllis to play the guitar. Phyllis would take her guitar to school and sing with Loretta Nester. The two would sing songs such as "The River of Jordan" and "Heaven." Phyllis married Carroll Eastridge and moved to Stuart in Patrick County, where she teaches at Patrick Henry Junior College. She currently plays with several bands. (Courtesy Phyllis Newman Eastridge.)

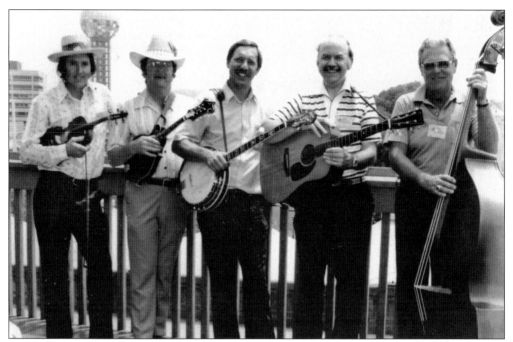

Bobby Patterson has been playing with the Highlanders for over 35 years all over the eastern states. Pictured here is the group at the 1982 World's Fair in Knoxville, Tennessee. From left to right, they are Buddy Pendleton (Stuart), Bobby Patterson (Carroll), Jimmy Zeh (Galax), Willard Gayheart (Galax), and Marvin Cockram (Meadows of Dan). Willard is also well known for his wonderful art. (Courtesy Lynne Zeh.)

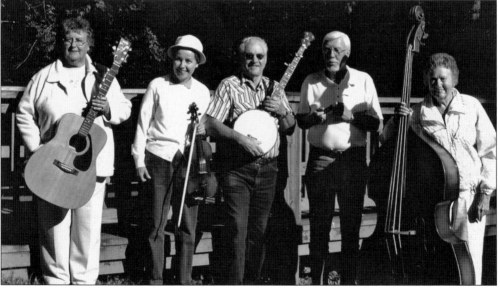

Mountain Ivy Band is an old-time band very much in the Galax tradition. All of the members have played with many others over the years. They have played regularly at Mabry's Mill on the Parkway for the last 15 years, where they go by the Mabry Mills Band. They are, from left to right, Annie Primm, Dea Felts, Melvin Felts, Kermit Waller, and Marie Gallimore. (Courtesy of Melvin and Dea Felts.)

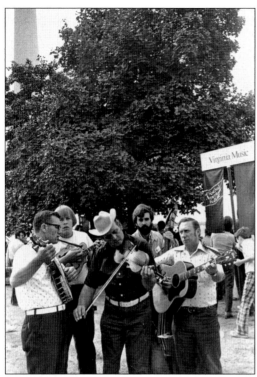

The Shady Mountain Ramblers featured, from left to right, an unidentified banjo player, Whit's son Mike Sizemore (mandolin), Whit "Big Howdy" Sizemore (fiddle), Dale Morris (bass), and Dan Williams (guitar). Tom Norman (not pictured) also played guitar. During the 1970s, they played the square dances at the Fairview Ruritan Club and the Hillsville VFW. The band had several first-place wins at fiddlers' conventions and played at the Folklife Festival in Washington, D.C. They made three LP recordings on the Heritage label. (Courtesy Dale Morris.)

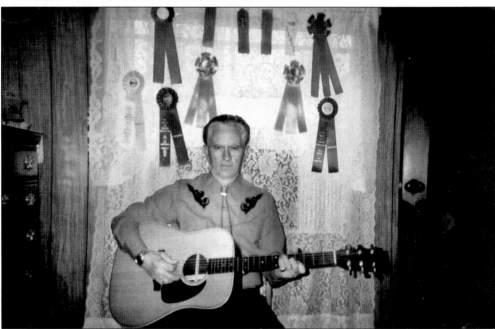

Roy Christian says, "I began playing at the age of six. My father and other family members were musicians. I am self taught. I've won numerous championships at fiddler's conventions everywhere. I played with Jim and Jesse, the 'Flat Ridge Boys' and numerous other groups. I enjoy playing at the VFW, senior citizens and the Andy Griffith Playhouse. I own a lot of guitars. My favorite is my D 28 Martin." (Courtesy Roy Christian.)

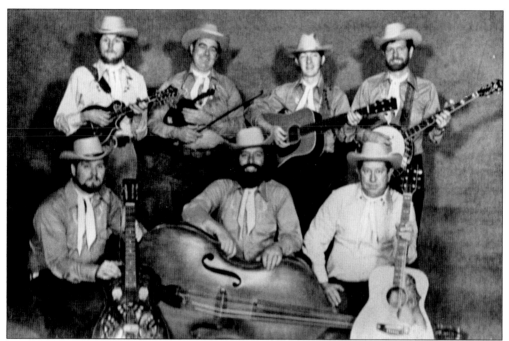

The Bluegrass Ramblers began playing in their teens. They got together in 1974 to jam and then formed a band. From left to right are (first row) Marvin Farmer (dobro), James Paul Ayres (bass), and Sylvan White (guitar); (second row) Dennis Vaughn (mandolin), Carlos Frost (fiddle), Lynn Dalton (guitar), and Tim Lineberry (banjo). They recorded a lot of songs they had written for *Bluegrass On and On* Heritage No. 1203 in 1978. (Courtesy Mark Sanderford.)

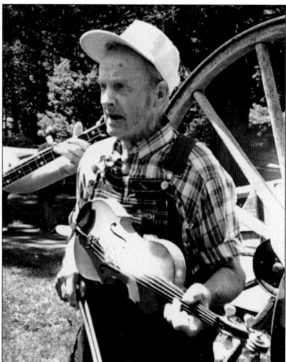

Arnold Spangler of Laurel Fork, Virginia, sang and fiddled in the style of J. E. Mainer in local shows and recordings with the Laurel Fork Travelers. He entertained tourists at Mabry Mill from the early 1900s until his death in 2004. When he was learning to play, his father would say, "Arnold, get in the other room and build up the fire, you're killing us with that fiddle." (Courtesy Melvin and Dea Felts.)

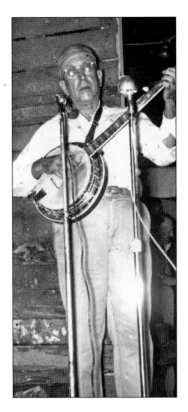

Pictured here is Dorsey Worrell of Carroll County. Dorsey, along with B. C. Goad (autoharp), Junior Ousley (guitar), and Homer Austin (bass), was with the Feed Room Five, formed in the early 1960s. Others who played with them were Glenn Smith, Dale and Marie Gallimore, Carl Harmon, Carl Nester, Roy Vass, Andy Sawyers, and Bobby Patterson. They played at many events and enjoyed taping a radio show as they practiced in neighbors' homes.

Some excellent musicians, for personal reasons, never travel far or become well known. Fiddler Orlus Nester was known at senior centers and local jam sessions for his infectious rhythm and precise timing as well as his quick sense of humor. A native of Dugspur, Virginia, Orlus played with a loose-knit group called the Carroll County Partners and composed a two-step tune called the "Carroll County Waltz." (Courtesy Melvin and Dea Felts.)

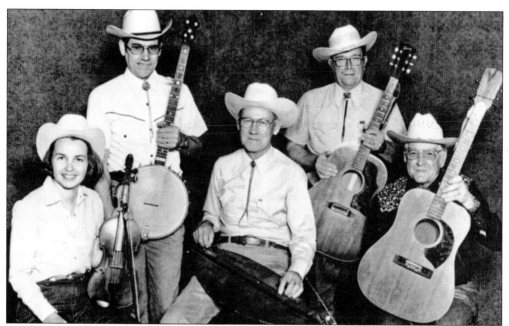

The Blue Sky Ramblers was an old-time band active in the 1980s in and around Carroll County. Shown from left to right are Dea Felts (fiddle), Melvin Felts (banjo), Raymond Melton (dulcimer), Munford Dillon (guitar), and Howard Dillon (guitar). Raymond Melton represents the third generation of Meltons who have been making dulcimers. The one Raymond is playing is an example of the teardrop shape peculiar to the Blue Ridge. (Courtesy Melvin and Dea Felts.)

Cody Thompson caught old-time music from several sides of his family. He is the nephew of well-known Galax-area musicians James and Joey Burris and grandnephew of banjo player Melvin Felts. His grandfather Dan Williams is an experienced guitar player. Cody won first place in the youth competition at Galax in 2006. (Courtesy Melvin and Dea Felts.)

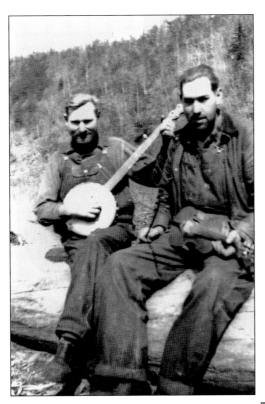

This picture of Charlie (1912–1988), left, and Oscar Sutphin (1914–1955) was taken around 1940. They lived on Big Reed Island Creek in Carroll County near the confluence of Greasy Creek. Charlie played the banjo and Oscar the fiddle. They played for dances held at different residences around the county and at family gatherings, usually on Saturday nights. (Courtesy Bobby Patterson.)

Eldon Gardner (born 1918) was born to C. C. Gardner and Ima Bowman of Laurel Fork. His father was a big influence on his life and his ability to play the harmonica. Eldon started playing when he was 10 years old. He played on the Grand Old Opry on his 70th birthday. Ralph Emery gave him a belt buckle and a hat, which he proudly wears.

Four

FLOYD COUNTY

Floyd County, crown of the Blue Ridge, was formed in 1831 from a portion of Montgomery County and was named in honor of John Floyd, then governor of Virginia. Floyd lies atop a high plateau in the Blue Ridge Mountains of Virginia. Floyd is a small rural county with only one stoplight and no four-lane roads. Buffalo Mountain at 3,971 feet dominates the landscape, along with beautiful forests, clean streams, and bountiful wildlife. The cultural heritage of music and flat-foot dancing explains the popularity of a weekly jamboree and other music venues. Floyd County is rich in singers, songwriters, musicians, and luthiers (instrument builders) who have passed the love of music down though the generations. Come and experience the old-time way through the pictures in this chapter.

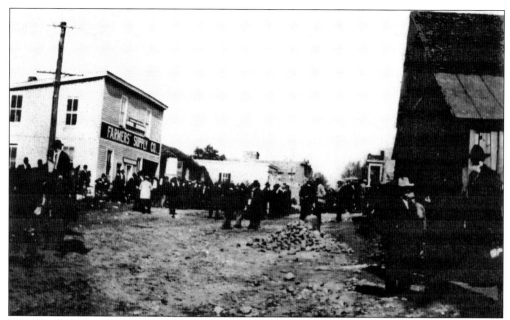

The Floyd Country Store, home of the Friday Night Jamboree, was constructed around 1910 and has been an important part of the community ever since. Freeman Cockram ran the place, Cockram's General Store, since 1984. Hubert Robertson and Cockram were the original founders of the jamboree. Cockram and Robertson would meet after closing time on Fridays to practice their music; pretty soon, locals starting beating on the door, wanting to be let in to listen to their music. Then other musicians started coming by to jam. Pretty soon, people starting dancing and hollering, and an institution was born. The jamboree has run for many years with "Granny Rules," which means no smoking, no drinking, no spitting, and no cussing. Woody Crenshaw and his wife, Jackie, bought the store in 2005. The Crenshaws spent two years renovating and revamping the old venue into a bona fide country store.

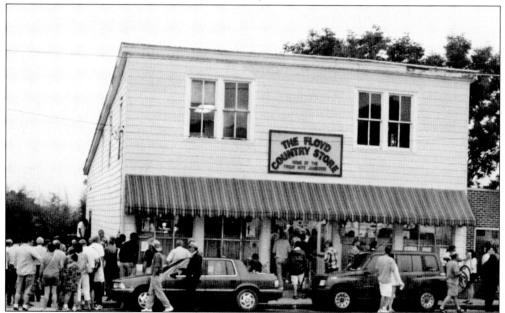

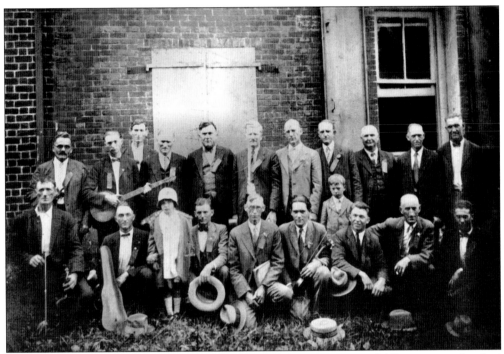

This group of men is gathered in Floyd around 1920 after competing in a fiddlers contest; they had their pictures taken in front of the old Farmers Supply Building. The identities of those pictured are unknown, except for Daniel "Doc" Poff, standing in the back row on the left. This picture was given to Woody and Jackie Crenshaw by J. C. Poff, whose grandfather was Doc Poff.

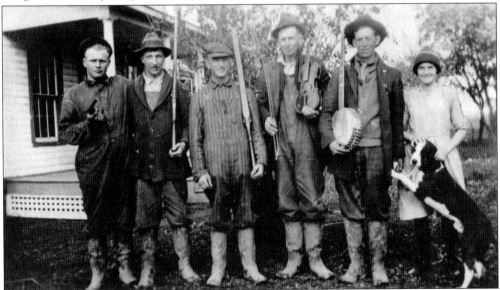

These gum-booted Floyd County men were seeking their fortunes and pursuing their favorite pastimes in Illinois about 1920. The man with the pistol, the woman, and the dog are unidentified. The others, from left to right, are (holding shotguns) brothers Hobert and Perry Marshall, Roscoe Reece holding the fiddle, and Clayton Bond with the banjo. Perry married and stayed in Illinois. The other three came back to live in Floyd County. (Courtesy Burnett Marshall.)

Golden Harris (1897–1964), a Primitive Baptist elder pictured here in 1923, drove to New York in 1931 to cut a record with the Brunswick Company on the Melotone label. In 1935, he recorded two Primitive Baptist hymns on the Harris label. He sold 500 copies of each record locally and by mail. Harris was honored in 1980 by having his records and a handbill placed in the Country Music Hall of Fame in Nashville, Tennessee. (Courtesy Mark Hodges.)

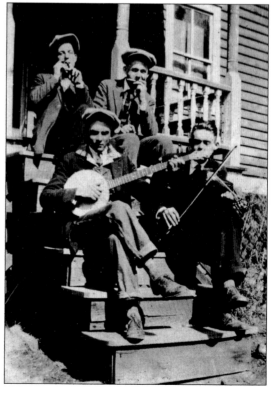

From left to right, Rollie Sutphin (banjo), Clevie Slusher (fiddle), Greek Criner (Jew's harp), and unidentified (harmonica) pose around 1928 on the front steps of Slusher's home, which once stood at what is now 679 Showalter Road in Indian Valley. (Courtesy Burnett Marshall.)

Rush Alderman from the Willis area is pictured here playing the guitar. He has played for many years with the Good Intentions, his son Lonzie's gospel group. (Courtesy Evalee Sutphin.)

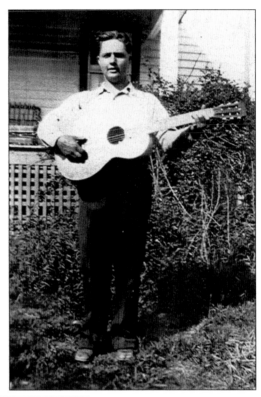

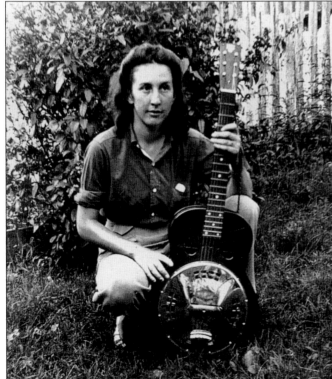

Irene Harris (shown in 1941 at age 20) of Willis, Virginia, has played music in the area and is well known for her guitar and harmonica playing. Her love of music began at an early age. She is always welcomed into any group of musicians jamming. (Courtesy Jackie Crenshaw.)

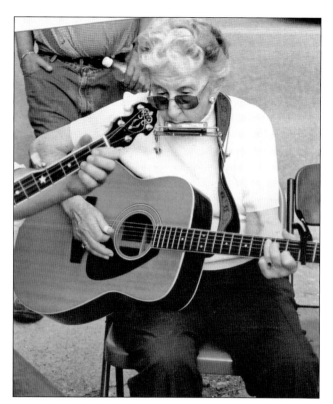

Irene Harris is pictured here at the Friday Night Jamboree at the Floyd Country Store; she is still going strong at 86 years young. (Courtesy Jackie Crenshaw.)

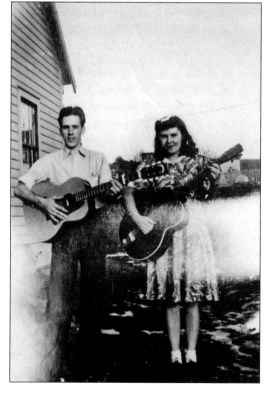

Fletcher and Versie Hollandworth Phillips, both of Indian Valley, were recently married when this picture was taken in 1941. Neither continued to play regularly, but two guitars and a book of hand-copied song lyrics from the 1930s were included in their estate sale. (Courtesy Ricky and Molly Cox.)

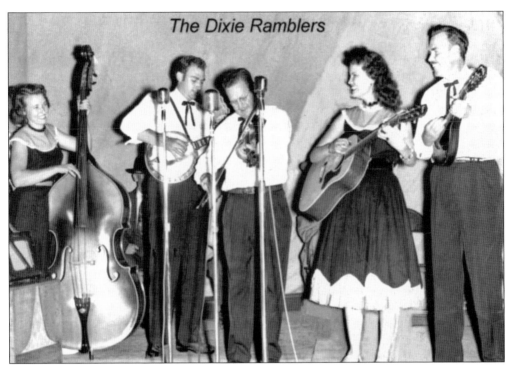

The Dixie Ramblers

The Dixie Ramblers were, from left to right, Marie Gallimore (bass), Olen Gardner (banjo), Wilson Ramey (fiddle), Maude Lowe (guitar), and Toby Lowe (mandolin). Marie was from Willis and often played with her husband, Dale, on the radio. They competed in separate bands in the 1950s, with Marie's group winning. She inspired Eric Reece to learn tenor when he stood next to her in the choir at church. (Courtesy Maude Lowe.)

"Farmer" Dale Gallimore opened Hillsville's first radio station—WHHV—and was known for his comedy skits on the air and as a great supporter of the traditional music in this area. Dale was master of ceremonies of the Galax Old Fiddlers Convention in the 1960s. He also started WGFC Radio in Floyd. He and Marie were members of the Feed Room Five, which entertained on the radio. (Courtesy Stanley Lorton.)

Randall Hylton (1946–2001) began playing guitar at age five and began writing songs at 12. He specialized in a finger-picking style fashioned after Chet Atkins and Merle Travis. He was known for being able to instantly write songs off the cuff. He recorded many CDs and wrote many songs. His song "The Room at the Top of the Stairs" was recorded by over 150 artists. He inspired many people from this area. (Courtesy Wanda Hylton Dalton.)

Randall Hylton poses with his first guitar, a blue and yellow ukulele, when he was about four years old. (Courtesy Wanda Hylton Dalton.)

Wanda June Hylton Dalton, Randall Hylton's sister, was also gifted with musical ability. She sang with her family and was a songwriter as well. One of her most famous songs, "Slippers With Wings," has been recorded by many bluegrass artists and can be heard at almost every festival as a standard. (Courtesy Wanda Hylton Dalton.)

Pictured from left to right are Lonzie Alderman (fiddle), Carlton Harmon (banjo), and Coy Keith (guitar). Lonzie also plays the 12-string guitar, Carlton the fiddle and guitar, and Coy the fiddle, mandolin, and banjo. (Courtesy Lonzie Alderman.)

Coy Keith poses with his father, Ed, on the banjo. Coy could play several instruments, including the fiddle, mandolin, and guitar, which he played Chet Atkins–style. Coy played with his cousins, who were all talented musicians. He was also a gifted songwriter. One of his songs was "When I Play My Guitar Someday In Gloryland." (Courtesy Kelvin and Teresa Keith.)

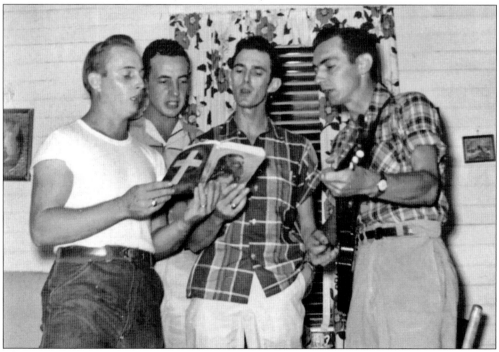

The Country Cousins were a group from Willis, Virginia, during the early 1950s. They are, from left to right, Lonzie Alderman, Dale Wade, Coy Keith, and Max Wade on guitar. They sang beautiful four-part harmony on the church hymns. (Courtesy Lonzie Alderman.)

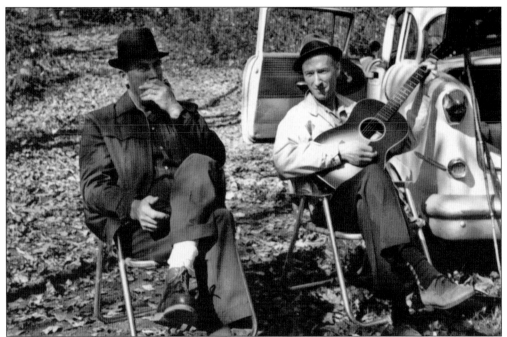

R. O. Slusher Jr. playing harmonica and Andy Hylton on guitar, first cousins and friends, are pictured on an outing with their families atop Buffalo Mountain in Floyd County in the 1960s. They were entertaining their families after a picnic lunch. Later they hiked up to the top of the mountain. R. O. was an accomplished guitar player and all-around good musician. His son, George, carries on this tradition, playing the guitar and mandolin. (Courtesy George Slusher.)

Playing music was a family affair. R. O.'s wife, Evelyn, plays the guitar while R. O. demonstrates the dancing dolls for a school group. R. O. was a craftsman and made the dolls. (Courtesy George Slusher.)

The Over the Hill Gang would meet every Thursday afternoon for almost a decade in the late 1980s and early 1990s and play. From left to right are Arnold Slusher, Stanley Lorton, Ralph Spradlin, Wilbur Weddle, R. O. Slusher Jr., and Max Wade (kneeling). This group played many years at nursing homes and churches. The only surviving members are Stanley and Wilbur. This talented group of musicians were always willing to give their time and talents to entertain. (Courtesy Stanley Lorton.)

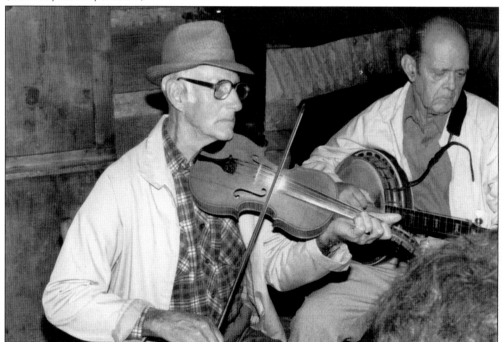

Ivan Weddle, seen here playing fiddle with Ed Keith, was always playing in the Willis community. Playing at an early age, music was as much a part of his life as breathing. (Courtesy Kelvin and Teresa Keith.)

Boss Cox from Indian Valley played the banjo the old-time way, in what is known as clawhammer style. He could also play the fiddle. Boss was an inspiration for his grandson, Alfred Cox, in learning to play music, because Boss showed him some chords and gave him a guitar to learn on. Alfred carried on the tradition his grandfather inspired. (Courtesy Diane Huff.)

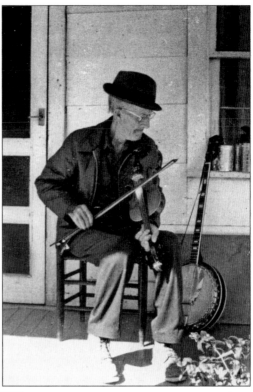

Alfred Cox learned to play the guitar at 14 when he was stricken with rheumatic fever for about two years. He played the guitar his grandfather Boss gave him. He also mastered the fiddle, mandolin, banjo, dobro, and bass. He became an instrument builder, making fiddles and mandolins. Alfred repairs instrument for his family and friends. He is passing his love of music on to his children and grandchildren. (Courtesy Diane Huff.)

Kelvin Keith of Willis, Virginia, plays the autoharp at about the age of eight. With him is Greg Howell, who grew up to play the guitar. Kelvin is the grandson of Ed Keith and the nephew of Coy Keith. They had a family group known as the Gospel Travelers. Kelvin's cousin Kendall Weddle also played in the group, along with Eric Reece on bass. (Courtesy Kelvin and Teresa Keith.)

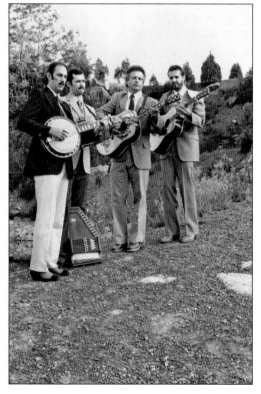

The Gospel Travelers are, from left to right, Coy Keith (banjo), Kelvin Keith (mandolin), J. C. Poff (guitar), and Kendall Weddle (bass guitar). This group played together until Coy's death. Kelvin and Kendall were Coy's nephews. (Courtesy Kelvin and Teresa Keith.)

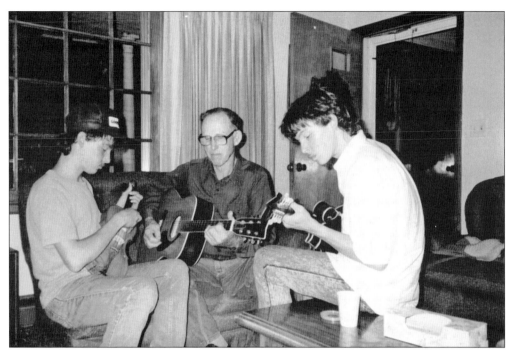

The Bolt twins—Sammy with the fiddle, Danny with the mandolin—pose with their mentor and teacher, Stanley Lorton. Sam and Dan learned very well; they are one of the top bluegrass bands from the Willis area, the Bolt Brothers Band. (Courtesy Stanley Lorton.)

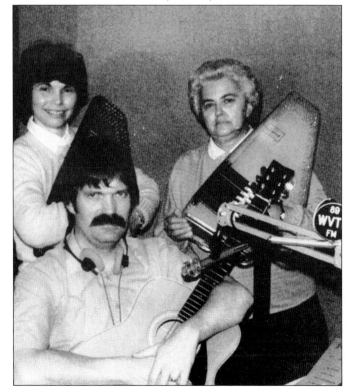

Mike Fenton (guitar), Bobbi Clifton (autoharp, left) and Betty Waldon (autoharp, right) play at a radio station in August 1986. Betty is from Floyd. She and Mike, among others, were instrumental in getting the autoharp competition started at the Galax Old Fiddlers' Convention. (Courtesy Bobbi Roberts.)

Eric Reece (guitar), seen here at Cockram's General Store at the Friday Night Jamboree, is practicing with, from left to right, Avis Sutphin (banjo), Stuart Bolt (bass), Danny Bolt (mandolin), and Sammy Bolt (fiddle), getting ready to play on stage. Eric has played the guitar since age seven and plays the mandolin, bass, and fiddle. (Courtesy Sandra Reece.)

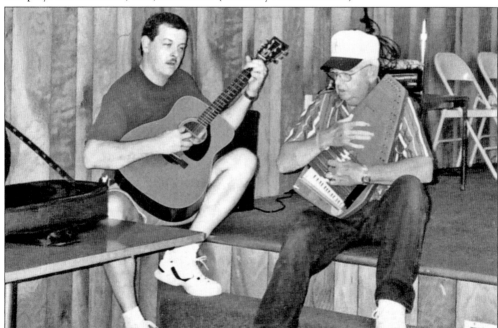

Eric Reece and his father, Ward, are entertaining at a family reunion. Eric is an accomplished songwriter, following in the footsteps of Randall Hylton, a major inspiration in his song writing. Eric uses Stanley Lorton instruments exclusively when he records or performs. (Courtesy Sandra Reece.)

John Reece (age three), son of Eric Reece of Floyd, is following in his father's footsteps and has taken an interest in the fiddle. His great-great-grandparents were all musicians. (Courtesy Sonya Reece.)

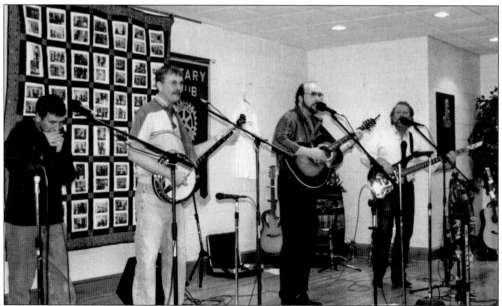

Upland Express is, from left to right, Dara James Orange, Barry Collins, Garry James Orange (Dara's father), and Gary Collins. Upland Express has been one of the best bluegrass bands for 37 years. Barry Collins is the only original member of the band. They have had members such as Ricky Simpkins and Ronnie Simpkins and undergone several revolutions. They are known for their distinctive vocal harmony. (Courtesy Gary Plaster.)

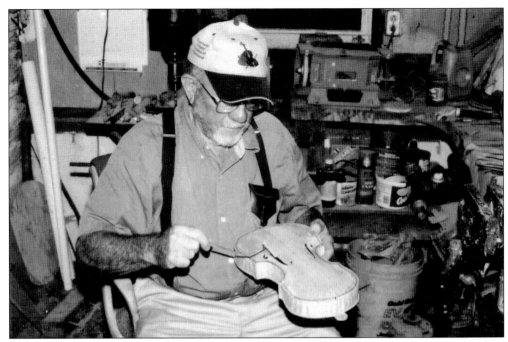

Arthur Conner (born 1924) of Floyd County began developing his craft in 1982 after deciding to make instruments for his children, teaching himself with the help of an instruction book on constructing fiddles. He has since made fiddles, violas, mandolins, cellos, basses, and a banjo. Arthur often carves the scroll of each custom-ordered instrument, usually in the shape of a ram. Since retiring, he devotes more time to making instruments and occasionally repair work for other people. Several area instrument makers, including Franklin County natives Billy Woods and Roy Hambrick, mention Arthur as an influence on their work. Pictured below from left to right are Mike Mitchell, Arthur Conner, and Mark Lewis. Mike and Mark are holding Arthur's fiddles. Mike and Mark both play several instruments and play together from time to time. Mike is the founder of Floyd Music School. (Courtesy Mike Mitchell.)

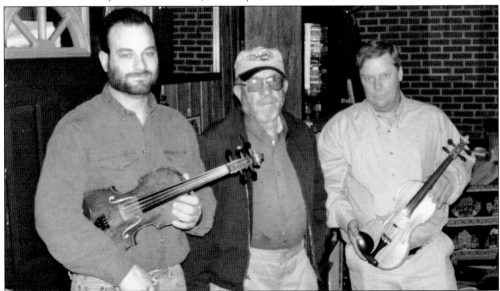

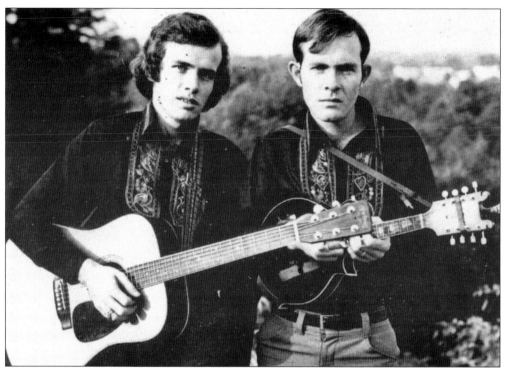

The Conner brothers—Arthur's sons Tommy (guitar) and Mickey (mandolin)—were part of the Floyd County Boys and later the Conner Brothers. The boys started playing at an early age, and Arthur remembers taking them to numerous festivals in Virginia and the Carolinas. The brothers have a wall of blue ribbons they have won at various festivals and contests, including a state championship. They loved listening to the Country Gentlemen. (Courtesy Mike Mitchell.)

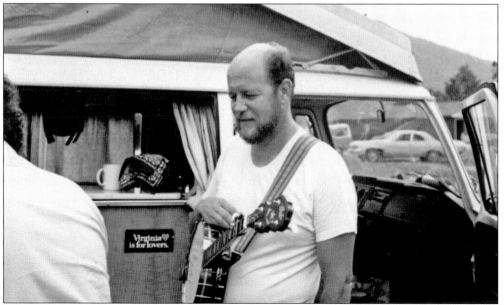

Bob Camp of Floyd was caught here at one of the Galax Old Fiddlers' Conventions. Bob loved the festival and could be seen jamming with different people. He was a very good banjo player.

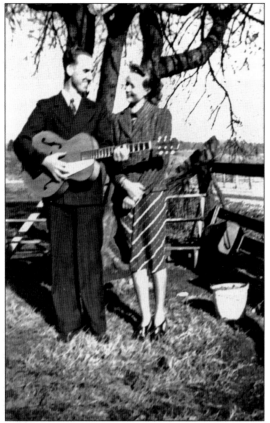

Stanley Lorton (born 1920) was one of seven children. He listened to the Grand Old Opry and became interested in music. As a teenager, he began playing the mandolin and guitar and played in a band. He is shown at left with his first wife, Eva, who enjoyed his music. In the 1980s, he became interested in making instruments, and the first one he made was a mandolin. Stanley has gone on to make fiddles, guitars, dulcimers, and dobros. All his instruments are made by hand the old-fashioned way. The work is time-consuming, but his love of being a master craftsman makes the time fly. He has made several left-handed mandolins. Will Farm (below) looks very satisfied with his left-handed mandolin. Stanley continues to play music of the 1920s and 1930s and gladly teaches anyone a song. He lives in Willis with his wife, Ruby. (Left courtesy Stanley Lorton; below courtesy Sandra Reece.)

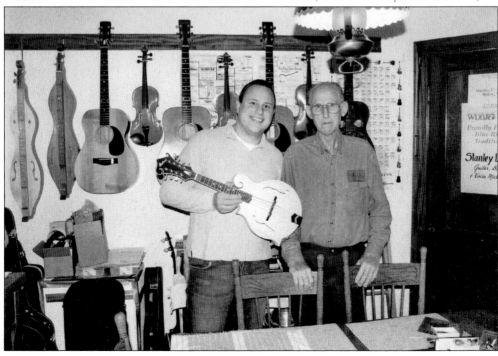

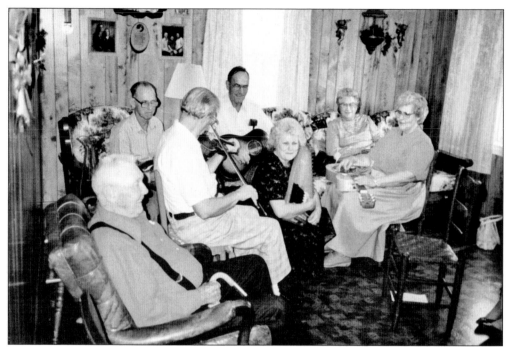

Part of the Over the Hill Gang is having a jam. From left to right are unidentified, Ralph Spreadlin (fiddle), Stanley Lorton (mandolin), R. O. Slusher Jr. (guitar), Janet Turner (autoharp), Ruby Lorton, and an unidentified woman holding a guitar. Janet had the Over the Hill Gang to back her up at various places. Janet is a well-known singer and autoharp player. (Courtesy Stanley Lorton.)

Coy Hylton (banjo) plays with the Bolt Brothers: Danny Bolt (mandolin), Stuart Bolt (bass), and Stanley Lorton (guitar). Not pictured is Sammy Bolt. Coy was a well-known banjo player with over 30 years' experience. He was always willing to share his time and talent with up-and-coming young musicians.

Josh Underwood (banjo), a former student of Carlton Harmon, is one of the most sought-after young banjo players. Josh is shown with Mike Mitchell (fiddle) demonstrating the new, progressive bluegrass style for which he is noted. Josh has played with several groups, including Make Shift and Statement. He can be found any given Friday night at the Floyd Country Store, on stage or jamming in the parking lot or upstairs. (Courtesy Sandra Reece.)

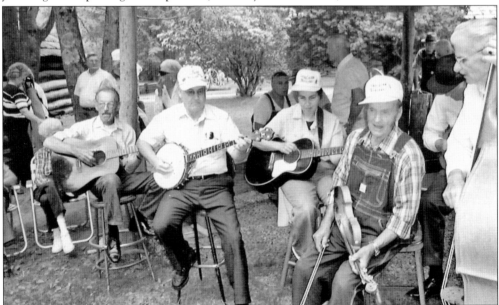

Most Sundays in May through October from 2:00 to 5:00 p.m., one can hear the sound of old-time or bluegrass at the Mabry's Mill on the Parkway at milepost 176. Visitors can bring a lawn chair and listen or step onto the boards and dance their hearts out. When Edwin Mabry built his water-powered mill, he had no way of knowing it would become one of the most photographed places in the United States.

Five

PATRICK COUNTY

Music runs through the veins of Patrick Countians. According to *A Guide to the Crooked Road*, Patrick County is "one of the most productive music thickets in North America." There is probably not a family who has not expressed their love of music by singing, playing or making musical instruments, clogging, flat-footing, or just enjoying the many music events throughout the county over the years.

Patrick County's rich musical heritage came with the first settlers, who brought along their folk ballads from Scotland, Ireland, Germany, and England; with Patrick Henry and his fiddle; and with hymns for worship. Gospel groups and church choirs continue to perform in the community. People sang ballads about events that actually happened. "The Wreck of Old '97," "Caty Sage," and "Freeda Bolt" were about a train wreck, a kidnapping, and a murder respectively. Music remains an integral part of the people's lives today. Denny Alley, a local musician and businessman, was instrumental in forming the Patrick County Music Association in 2003. Local talent, as well as the famous, performs on the stage at the Rotary Field the fourth Saturday night of each month, drawing record crowds. Denny's goal is to showcase the wealth of Patrick County's musical talent. A music trail winds through the heart of Patrick County, where the toe-tapping rhythm never misses a beat.

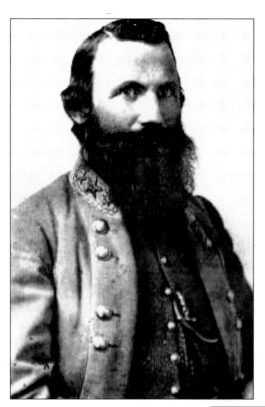

J. E. B. Stuart from Patrick County was famous as a Confederate Civil War general. He was also a fan of old-time music and a fiddle player himself. During the war, he had an old-time band that entertained his troops when they had a quiet time between battles. (Courtesy Tom Perry.)

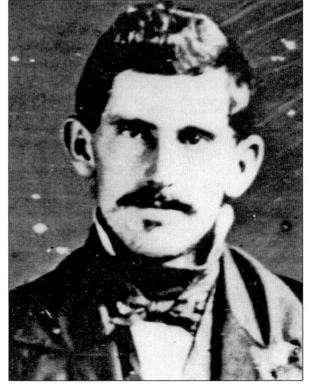

Sam Sweeny was a talented fiddle and banjo player. His father, Joe Sweeny, was the earliest known person to have played banjo on stage. During the Civil War, Sam enlisted in the 2nd Virginia Cavalry and became known through his association with the famed Confederate officer J. E. B. Stuart. Stuart saw to it that Sweeny was attached to his headquarters entourage because of his banjo playing. Sam's signature song was "Jine The Cavalry," which was possibly penned by J. E. B. Stuart. (Courtesy Tom Perry.)

Shape Note Singing School was open from approximately 1915 into the 1920s. Here singing master William "Bill" Ellis Shelor stands to the left of the students. (Courtesy James Shelor.)

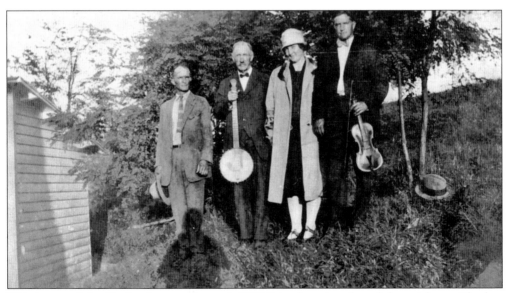

This image of the Blackards was taken at a 1927 Bristol session: from left to right are Phythus Shelor, Joe Blackard (1859–1949), Clarice Blackard Shelor, and Jessie Shelor. On August 2 and 3, 1927, the Shelor-Blackard family appeared and recorded four record sides. All seven sons and some daughters of William Shelor played instruments and sang harmony. (Courtesy James Shelor.)

Pictured here are Flem "Jefferson" Howell and Lucinda Hylton Howell in 1962. Flem was a fiddle, guitar, and banjo player in the old-time tradition. He was never a professional musician, but he played with Charlie Poole when Poole's band came through the area. His musical descendants include his son, Cruise Howell, and two grandsons, Thurston "Ted" Conner (a well-known classical guitarist) and Sammy Shelor (an award-winning bluegrass banjo player). (Courtesy Leslie Shelor.)

Cruise Howell is pictured in 1940 with his wife, Ruby, and daughter LaNita. Cruise learned to play banjo from his father, Jeff. He played guitar with his father and Charlie Poole. Cruise was also known for making beautiful banjos. Twenty of his instruments still exist in the hands of collectors and family members. He used curly maple wood from the area and mother-of-pearl inlay. He made at least one guitar from the soundboard of an old piano. (Courtesy Leslie Shelor.)

Lupert Morton Clifton was born in Patrick County, Virginia, in 1873 and became a well-known fiddle player in his family. When he wasn't playing his fiddle, he could usually be found out quail hunting. (Courtesy Nettie Clifton.)

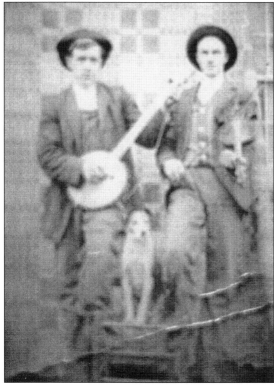

Two Early Patrick County musicians, Taylor Kimble (banjo) and Henry Burnette (fiddle), pose with man's best friend, sitting in the middle listening. (Courtesy of Tom Perry.)

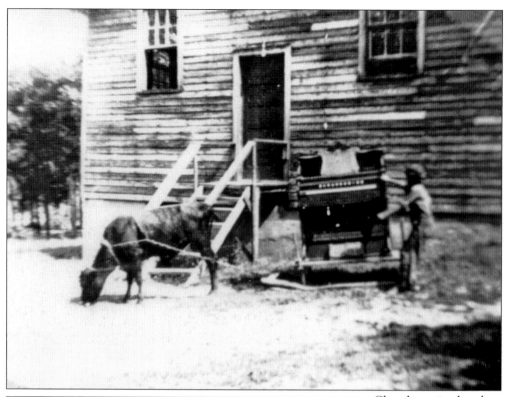

Church music played an important part in Patrick County history. Above, Wesley Young hauls the organ of the Moals Griffin family to Ravin Rock Methodist Church in 1930. (Courtesy of Tom Perry.)

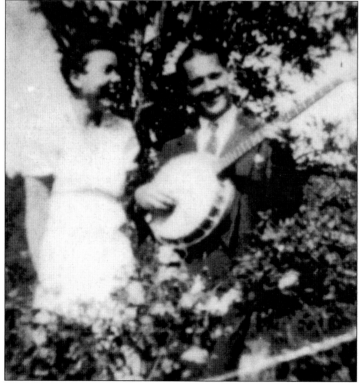

Charlie Bowman (banjo) entertains Lola Jessup McMillan with a banjo tune. Both are from Ararat, Virginia. (Courtesy Barbara Bowman Clement.)

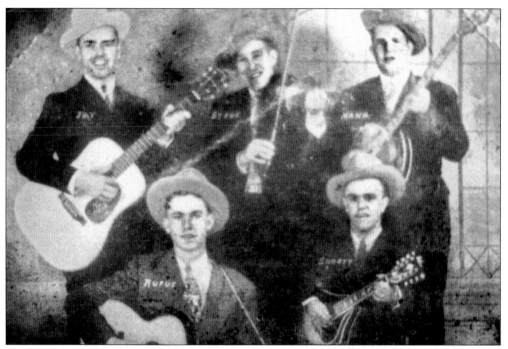

Hugh and the Happy Go Lucky Boys was an early music band from Patrick County. They played at many local and social events. (Courtesy Tom Perry.)

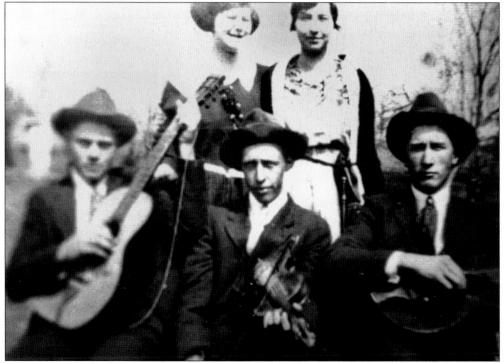

Shown are, from left to right, (first row) Frank Beasley, Johnny Draughn, and an unidentified friend; (second row) Bessie Beasley and Geneva Draughn. (Courtesy Tom Perry.)

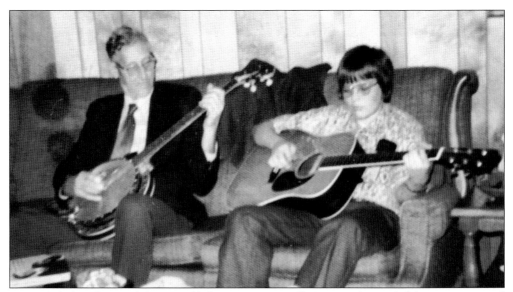

Sammy Shelor plays with his grandfather Cruise Howell. Sammy descended from two musical families, the Howells and Blackards. Cruise sparked Sammy's interest at age six by making him a child-size banjo from found materials, including coat hangers and part of an old pressure-cooker. Sammy's career has spanned decades of success, with four consecutive International Bluegrass Musicians' Association Banjo Player of the Year awards and numerous Society for the Preservation of Blue Grass Music Association awards. He is now leader of the Lonesome River Band. (Courtesy Leslie Shelor.)

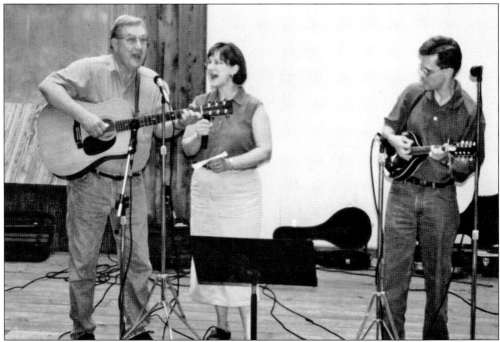

James Shelor (guitar), Amy Shelor Clark (singing), and Clay Shelor (mandolin) are all descendants of William Ellis Shelor. (Courtesy James Shelor.)

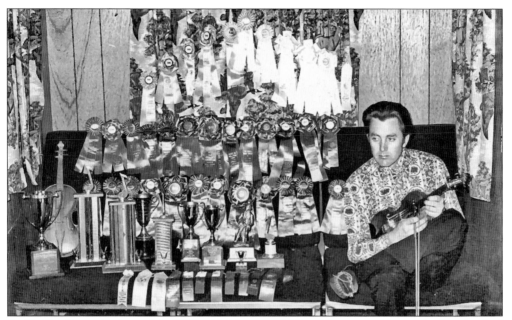

Buddy Pendleton is pictured in 1972 with bluegrass fiddle ribbons, trophies, and a handcrafted fiddle he made himself. He was voted World Fiddle Champion by the Union Grove Fiddlers' Convention in 1972 and 1973. He learned to play the fiddle at the age of 12. In the early 1960s, he toured with Bill Monroe and Joan Baez, appeared on television, and became leader of the bluegrass group Dixie Gentleman of Virginia. (Courtesy Buddy Pendleton.)

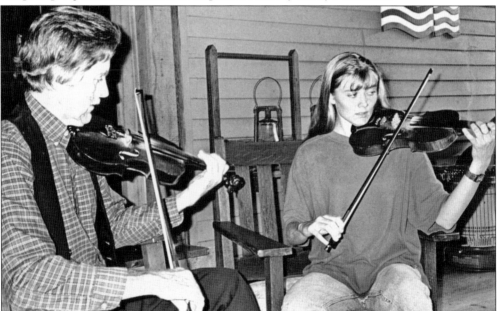

Buddy Pendleton is playing fiddle here along with his daughter Robin. Buddy has been a hot fiddler in the area for many years. In the mid-1960s, he recorded an LP with County Records along with Larry Richardson and Red Barkers. He was also featured on an LP that presented some of the top fiddlers in the Galax area. He has played with many bluegrass bands, including Bill Monroe. (Courtesy of Denny Alley.)

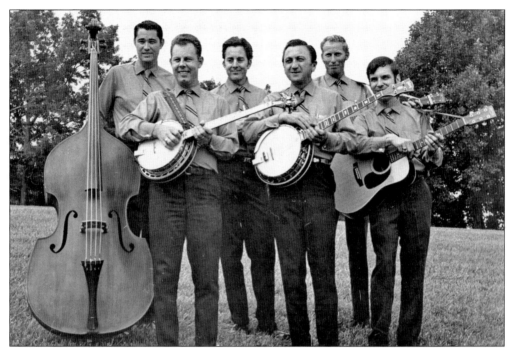

Here are the Dixie Gentleman. They are all from Patrick County and are one of the county's earliest bands. Garlin Cockeram (bass) is from Woolwine, as is Buddy Pendleton on fiddle (middle, second row) and Ralph Hayden on guitar (right, second row). Dean Shelton (left, first row) is from Patrick Springs, and Larry Martin is playing banjo (middle, first row). The guitar player at right is unidentified. They have made many recordings.

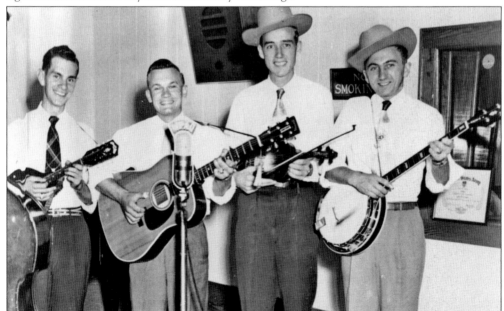

The Southern Partners are one of the earlier bands of Patrick County. They made records back in the 1940s. Pictured from left to right are Coy Hall, bass; Lloyd Burge, mandolin; Marion Hall, guitar; Joyce Brammer, fiddle; and Troy Brammer.

Dudley "Babe" Spangler, whose daughter Bernice was still living in the Meadows of Dan in 2008, played with Cabell Hylton from time to time as well as members of the Shelor family. (Courtesy Denny Alley.)

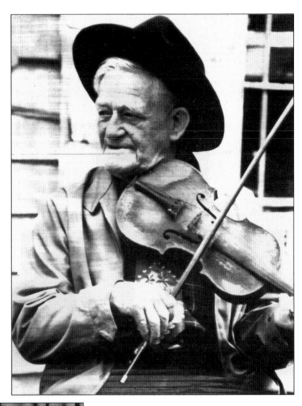

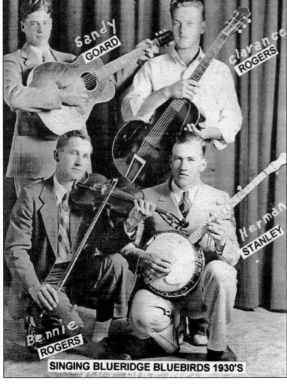

SINGING BLUERIDGE BLUEBIRDS 1930'S

Here is another example of an early band in Patrick County, the Singing Blue Ridge Bluebirds. They were popular in the 1930s, playing barn dances all over the county. Sandy Goard was an important part of this band until he went in the army. He was a World War I veteran. This was one of the first organized bands in the county. (Courtesy Denny Alley.)

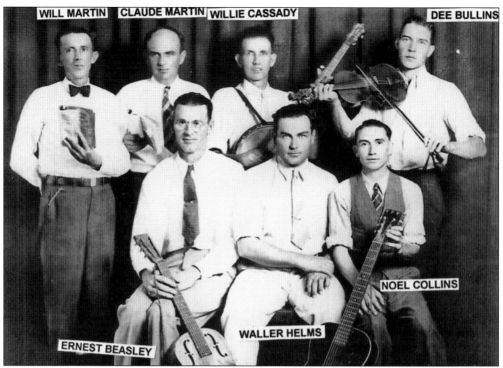

Patrick County String Band was popular in the area in the 1930s, showing the deep roots of this music.

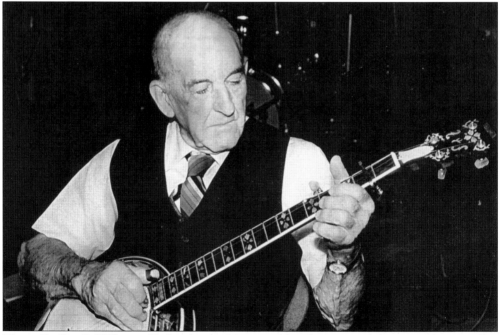

This is Dudley S. Williams. He lived to be 96 years old and was one of the original Trot Valley Boys. He made many banjos and guitars. He and his wife had 11 children. Two of them still play in the area; Clyde Williams plays guitar and Sadie Martin plays bass.

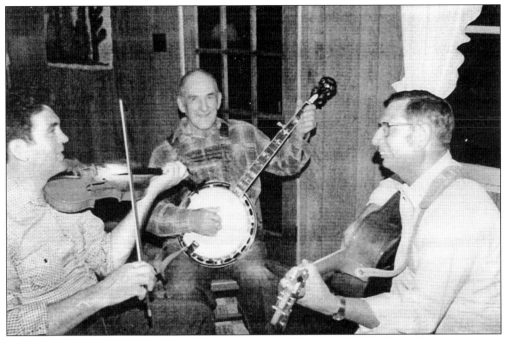

The Trot Valley Boys were a popular band in the area. Here Dudley Williams is playing the guitar. He made many instruments, including four brass fiddles. Raymond Hall is on guitar, and Winford Gunner is playing a fiddle he made. Winford made many fiddles in his time, usually out of curly maple. He worked maintaining a boiler at J. P. Stevens, a company in North Carolina. He would take the wood he was making the sides out of, soak it, and then put it on the right-sized steam pipe to bend it properly.

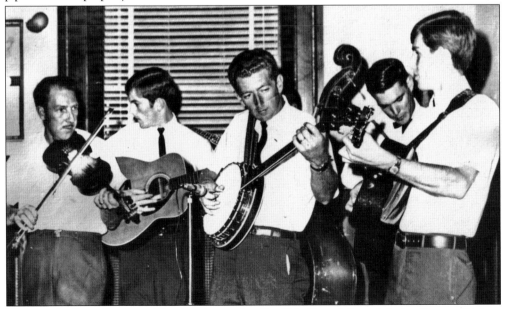

Here are the Joyce Brothers. This band was a family affair. From left to right are Herman Dalton on fiddle, brothers Johnny and Camden Joyce on guitar and banjo respectively, Mike Hazelwood, and Herman Dalton's son Everett.

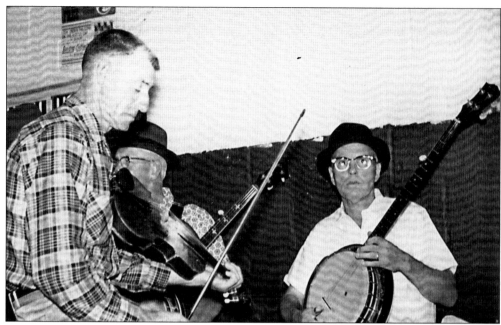

In another example of jamming, Cabell Hylton of Patrick Springs plays the fiddle and Paul McPeake plays fingerstyle banjo. Cabell (1907–1983) had a great reputation as a fiddler. He and his two brothers played, especially at dances. Cabell liked to play tunes like "Richmond," "Wednesday Waltz," and "Fortune." He also played clawhammer-style banjo. Cabell was related to the McPeakes and probably played with them a lot. (Courtesy Denny Alley.)

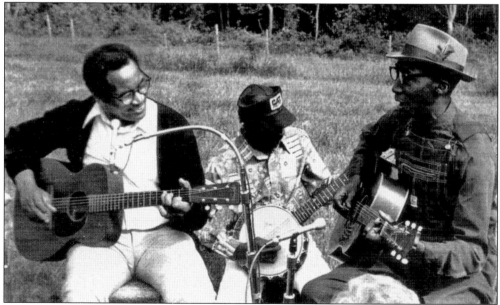

The late Marvin and Turner Foddrell, in a tradition begun by their father, Posey Foddrell, were popular Piedmont blues–style musicians who played in the Patrick County area for many years. They performed at the Blue Ridge Folklife Festival in Ferrum, at the World's Fair in Knoxville, and in Europe. Pictured from left to right are Marvin, Turner, and Posey playing at home in the 1980s. Lynn, Turner's son, carries on the musical tradition. (Courtesy Phyllis Newman Eastridge.)

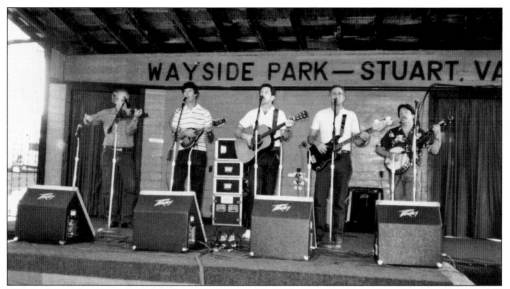

This is an early version of the Country Boys with Dale Fain on banjo. He has lived in Patrick County all his live. He now plays with church groups. Mike Hazelwood is on mandolin. He is a carpenter, has written several songs, and has played with the Old Dominion Boys. The fiddle player is thought to be Buddy Pendleton. Everett Dalton (middle) is playing guitar. He lives in Tobaccoville now. He has played with numerous groups. Johnny Joyce is also on guitar. He is a mailman in Patrick County and has kept the Country Boys group active with a compact disc called *The Country Boys Sing Bluegrass and Gospel.* (Courtesy Denny Alley.)

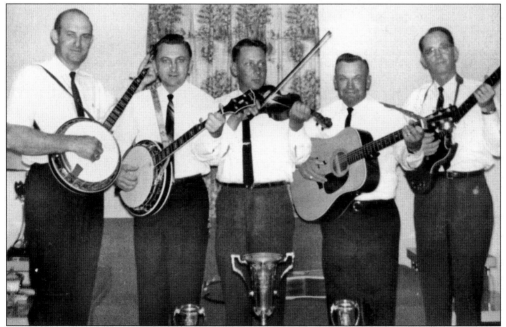

This band was formed to compete at conventions. They won first place at the Union Grove Fiddlers' Competition. From left to right are Clarence Hall on banjo, Troy Brammer on banjo, Willy Gregory on fiddle (the father of Clinton Gregory, who has placed first fiddle at Galax), Marian Hall on guitar, and Coy Hall on bass. (Courtesy Denny Alley.)

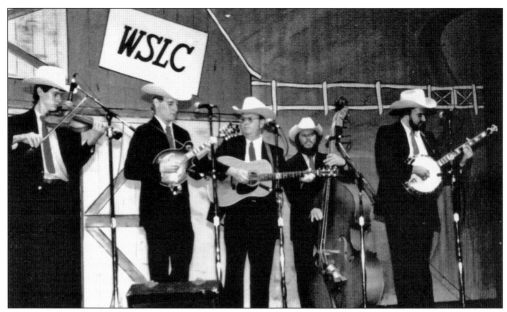

Blue Knight was a local band whose picture was taken in 1986 at the Roanoke Civic Center in Roanoke, Virginia. Seen here are fiddler Jim Skelding, Kevin Joyce (mandolin), Leon Pollard (guitar), Jimmy Handy (bass), and Charlie Chaney on banjo. (Courtesy Denny Alley.)

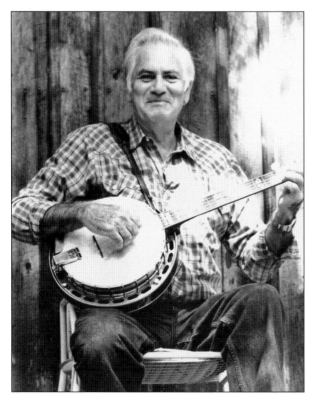

This is Clay Wood. Besides playing music, he is also part of the legendary Wood family. Glenn and Leonard Wood of Patrick County were brothers famous for their racecar exploits. (Courtesy Denny Alley.)

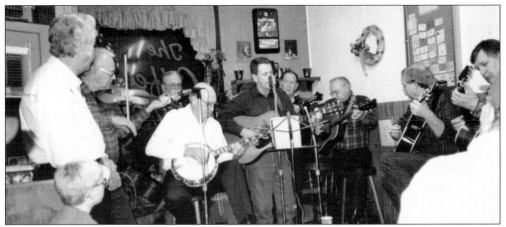

The Patrick County Music Association, known to everyone as PCMA, had its beginning long before the name was coined about five years ago. It started as a small gathering of pickers, singers, and fans of bluegrass/gospel music almost 16 years ago in the Coffee Break restaurant on Main Street in Stuart, Virginia. Five years ago, the idea of expanding PCMA was discussed by a number of local musicians, and they were encouraged by others to start a gathering of music folks in a larger setting, on a regular schedule, and with a formal organization. Thus PCMA took root, and the growth has been extraordinary. Performances are monthly, bands are eager to perform, and a gathering of fans seems to have no limits. The largest monthly performances include up to 10 or 12 bands with 1,000 or more people attending and a number of auxiliary activities. Performances were first held in the Hooker Building at Stuart Rotary Field but are now held in the adjacent Rotary Memorial Building to accommodate more people. (Courtesy Denny Alley.)

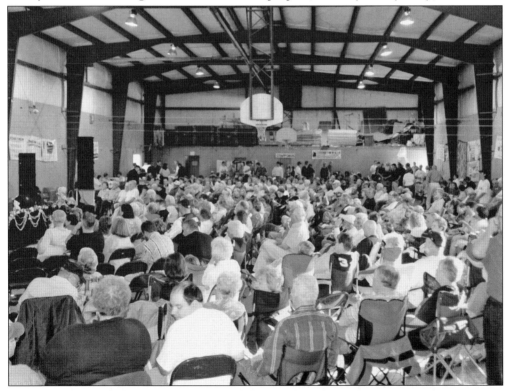

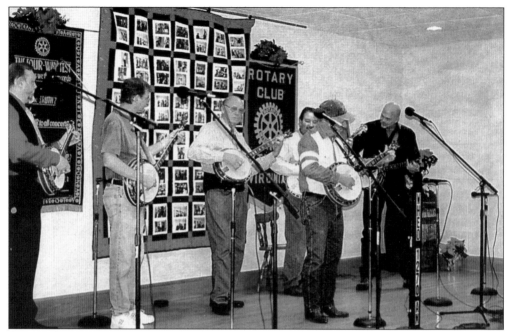

Pictured here from left to right are Snuffy Smith, Barry Collins, Clarence Hall, Daryl McCumbers, Tommy Moss, and Sammy Shelor. This was part of an amazing banjo concert. Those who attended said it was amazing to hear that many different styles of banjo being played and still blending so well. (Courtesy Denny Alley.)

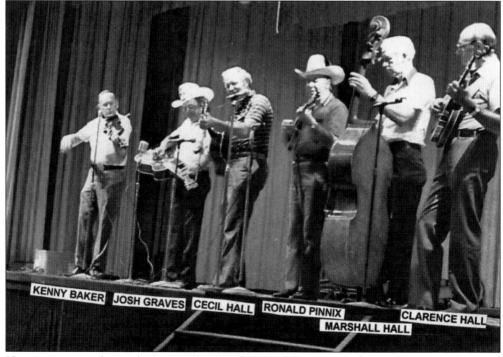

Here is a concert that took place at Floyd High School. Pictured are Ronald Pinnix and cousins from Patrick County with Marshall and Clarence Hall. (Courtesy Denny Alley.)

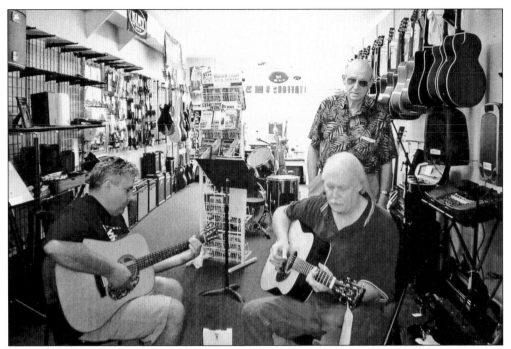

Kenny Smith (left) jams with Denny Alley. This is reflective of the early days, from which the idea of the PCMA was born. Clarence Hall is looking on as they jam at the Stafford Music Store, right next to the Coffee Break in Stuart. (Courtesy Denny Alley.)

Here is part of the Country Gentlemen band jamming backstage before a concert. Pictured with Denny Alley (center) are Randy Waller (right) on guitar and Mark Delany. This is an example of the quality of groups PCMA has brought to Patrick County to be enjoyed by the people from all around. (Courtesy Denny Alley.)

One of the national bluegrass acts that has two natives of Patrick County as part of the group is the Lost and Found. Pictured here on the left is Dempsey Young, who lives in Woolwine, and Allen Mills, also from Woolwine, on the right. Dempsey died on December 10, 2006. He is honored on the band's Web site as "defining the Lost and Found's sound for 33 years." (Courtesy Denny Alley.)

Here is another example of a national act brought to Patrick County. The famous Mac Weisman (center) plays with Darrell McCumbers on banjo and others from the Patrick area.

Here is a good representation of talent being shown at one of the association's gatherings. This was a Thanksgiving show. On the stage can be seen, from left to right, unidentified, Denny Alley, Marvin Cockram, Wayne Henderson, Vince Bullins, and Charlie Cheney. (Courtesy Denny Alley.)

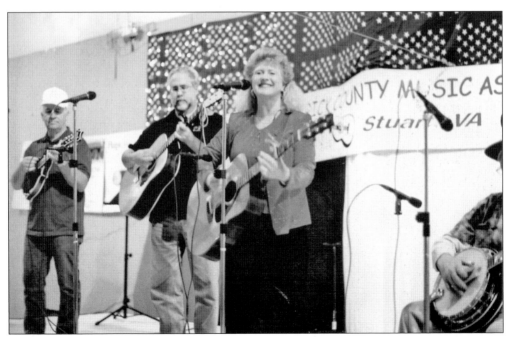

The fourth Saturday night of the month brings all kinds of local talent to the PCMA. Here are Sue Nester, Mike Cummins on guitar, and Darrell McCumbers on mandolin.

Cap Ayers, a friendly man, plays the banjo, guitar, autoharp, and kazoo. Cap can be heard on about a dozen tunes on the *Carter-Owen Project*. His playing is unobtrusive, a refection of his easygoing nature. He is pictured at a family reunion listening to Ed Keith. (Courtesy Kelvin and Teresa Keith.)

Fife and drum bands were known to have played at community events on the western side of Patrick County well into the 1900s. Matt Hopkins (large drum), a second drummer, and a fifer (possibly in uniform) appear in this rare photograph taken at the Green Dehart home place in the Lone Ivy section about 1920. (Courtesy Phyllis Newman Eastridge.)

Phyllis Newman Eastridge plays with many bands. Here is one from bygone days in 1968. From left to right are Bob Dickins, Craig Dickins, Phyllis, and "Preacher" Jones singing in a gospel group in Mount Airy, North Carolina. Phyllis is a familiar face in Patrick County. According to Denny Alley, she does a comedy skit that usually brings down the house. (Courtesy Phyllis Eastridge.)

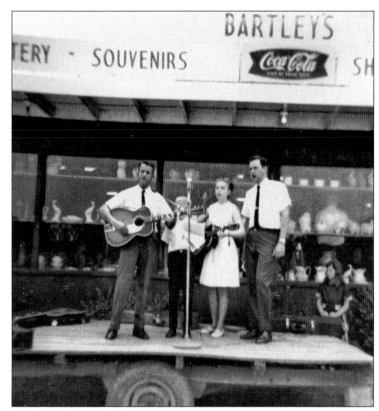

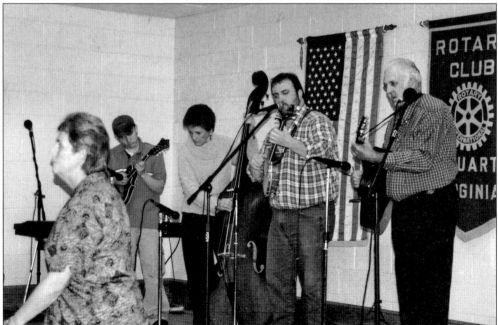

Brien Fain (banjo) and Robert Hall (guitar) play for the PCMA. Brien is an old-time banjo player and can be see playing from the Blue Ridge Music Center to Patrick and everywhere in between. (Courtesy Gary Plaster.)

Pictured are Wayne Henderson (left) and Denny Alley playing at PCMA. Wayne is a fine example of the talent that can be seen any fourth Saturday night of the month. Denny is constantly searching for local talent to fill the lineup. He believes in giving anyone who comes a try. (Courtesy Gary Plaster.)

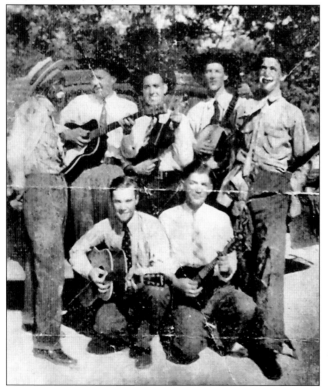

Charlie Bowman and his Blue Ridge Ramblers are shown here for a picture for WAIR Winston-Salem, North Carolina. From left to right are (first row) Wallace Cook (guitar) and Willard Smith (mandolin); (second row) Donald Phillips (guitar), Cabot Enman (fiddle), Orlus Nester (banjo), Charlie Bowman, and clown Edgar Smith. (Courtesy Melvin and Dea Felts.)

The Kenny and Amanda Smith Band performs in 2006 at the PCMA. They usually do a special Christmas show every year. This group is always willing to give back to the community where they live. (Courtesy Gary Plaster.)

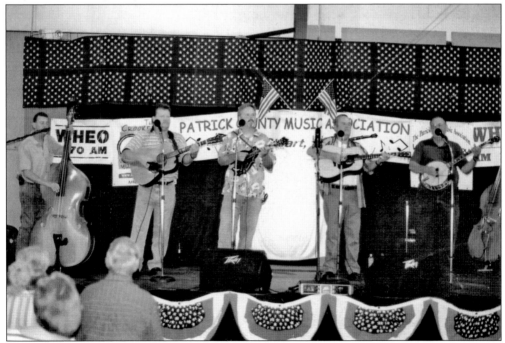

Kopper Kanyon—Charlie Chaney (banjo), Vince Bullins (mandolin), Timmy Jefferys (bass), and Keith Pyrtle (guitar at left)—are an up-and-coming bluegrass band that has played all across the Carolinas and Virginia. (Courtesy Gary Plaster.)

ACROSS AMERICA, PEOPLE ARE DISCOVERING SOMETHING WONDERFUL. *THEIR HERITAGE.*

Arcadia Publishing is the leading local history publisher in the United States. With more than 4,000 titles in print and hundreds of new titles released every year, Arcadia has extensive specialized experience chronicling the history of communities and celebrating America's hidden stories, bringing to life the people, places, and events from the past. To discover the history of other communities across the nation, please visit:

www.arcadiapublishing.com

Customized search tools allow you to find regional history books about the town where you grew up, the cities where your friends and family live, the town where your parents met, or even that retirement spot you've been dreaming about.

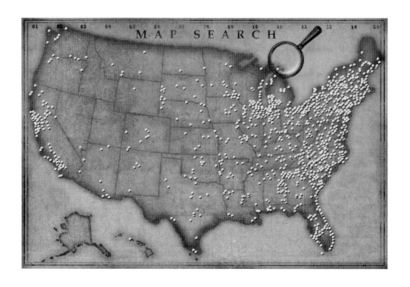